Saxophone Colossus:
A Portrait of Sonny Rollins

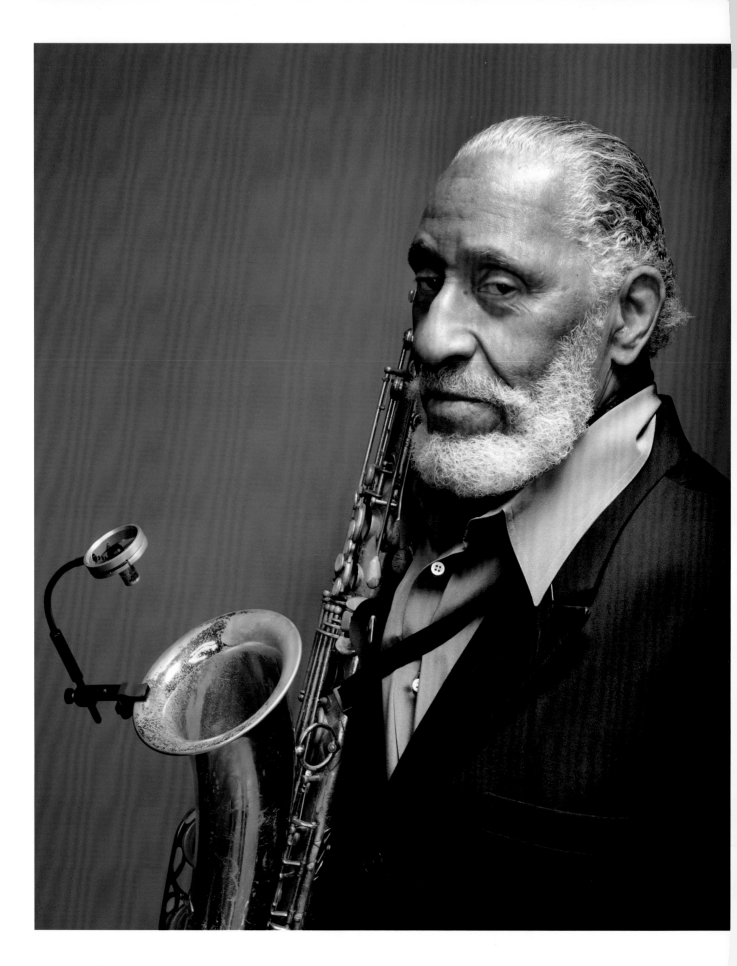

Saxophone Colossus: A Portrait of Sonny Rollins

Photographs by John Abbott *Text by* Bob Blumenthal

ABRAMS, NEW YORK

For Robin—my beautiful and brilliant wife. JOHN ABBOTT

For my mother and the memory of my father. BOB BLUMENTHAL

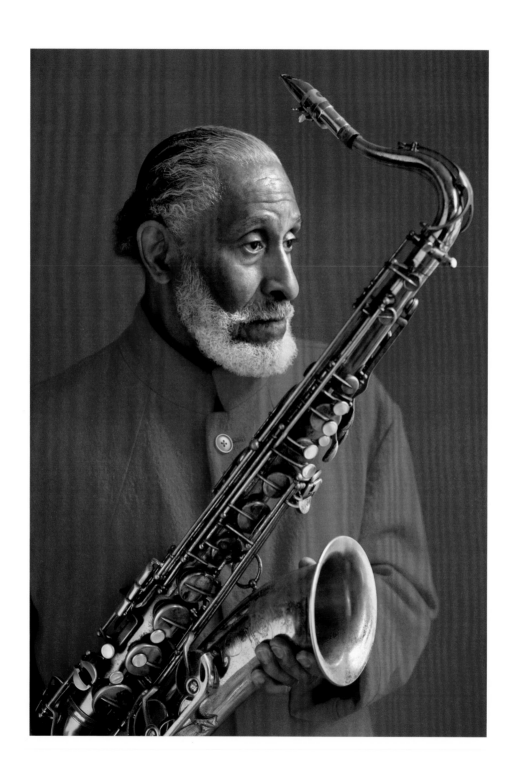

Table *of* Contents

This book has two sources of inspiration. First is *The Private World of Pablo Picasso*, a lovely book by David Douglas Duncan from 1958. Duncan photographed Picasso's essence as a mature artist, surrounded by his family and his dogs, and continuing to capture the beauty of the world in his art. Second, naturally, is the music of Sonny Rollins. It is the sound of inspiration itself. I am forever grateful for the opportunity to show people through this book what a great artist looks like.

It has been an extraordinary privilege to have spent time with Sonny. His stature as a jazz giant is matched by his sensitive and kind personality. Warmth, charisma, confidence—these are all words that come to mind when I reflect on the moments I have shared with him.

Luckily for me, these characteristics, borne out of his many years as a gentleman and as a musician, extend to his visual presence. He turned our lengthy photo shoot at his home in August 1995 into an ecstatic, revelatory afternoon, full of long shadows, warm light, and Cole Porter sing-alongs at the piano. He was the first man to give me a call and wish me well after my neurosurgery in 1994. He has been particularly insightful and insightfully particular about his wardrobe on and off the stage. Countless anecdotes and stories from our times together have enlightened me as powerfully as has his music.

I have photographed Sonny on and off the concert stage for nearly twenty years. Every experience has been a highlight of my life, as an artist and as a man.

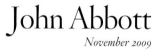

John Abbott

November 2009

I first heard Sonny Rollins in 1960, when I was thirteen and just getting acquainted with jazz. He was featured on several of the first albums I purchased, creating a spectacular "Bags' Groove" solo in concert with the Modern Jazz Quartet, playing and composing "Airegin," "Oleo," and "Doxy" with Miles Davis, hurtling through "The Way You Look Tonight" and "I Want to Be Happy" in a quartet that also featured Thelonious Monk. By the time I first heard Rollins in person two and a half years later, playing some of his same originals with his *Our Man in Jazz* band, I had tracked down the *Saxophone Colossus* album and most of his other early triumphs.

The incredible way Rollins played was enough to make him an immediate favorite, and my appreciation and respect only grew as I read of his rigorous standards and refusal to accept popular success at face value. Even for a non-musician like myself, Sonny Rollins offered an inspiring example. In the four decades that I have been writing about music, and the more than thirty-five years since I first met Rollins, that inspiration and example have never dimmed.

When he first suggested a book about Sonny Rollins, it became clear that John Abbott shared similar feelings and approached his work in a common spirit. Beyond the gift of John's eye and skill in the photographic medium, his flexibility and willingness to take risks helped us arrive at the idea that motivates the present book.

Saxophone Colossus is not one of those "making of" volumes, where the particulars of an iconic jazz recording are chronicled in documentary order. Instead, it employs the structure of that classic album to give shape to what I hear, and what John sees, in all of Sonny Rollins' music. This led me to discuss many other memorable Rollins performances, which are listed in their most common release in the appendix.

All of the quoted material comes from personal interviews and conversations with Rollins in 1973, 1978, 1991, 1998, and 2009. I must emphasize that, while a person who has been so pivotal in shaping my tastes is in one sense responsible for the opinions expressed herein, Sonny Rollins did not authorize these opinions. He did give John and me his blessing when we explained our intent, and we thank him for that. We trust that what follows reflects feelings many share as Sonny Rollins enters his ninth decade, still blowing.

Bob Blumenthal
November 2009

St.
THOMAS
ROLLINS & RHYTHM

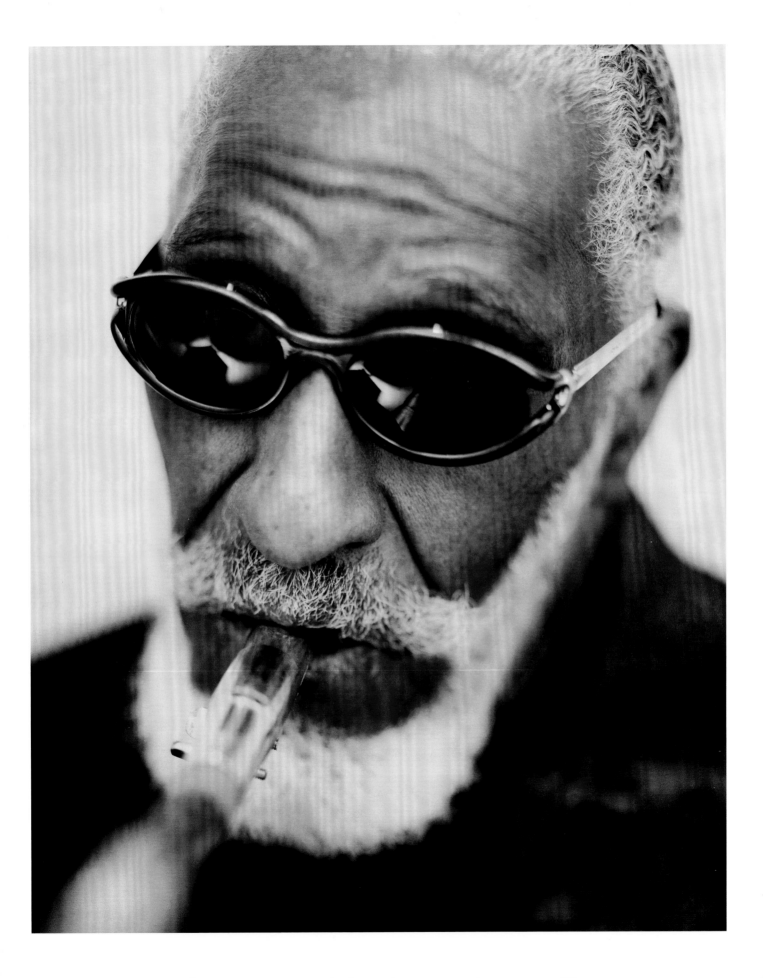

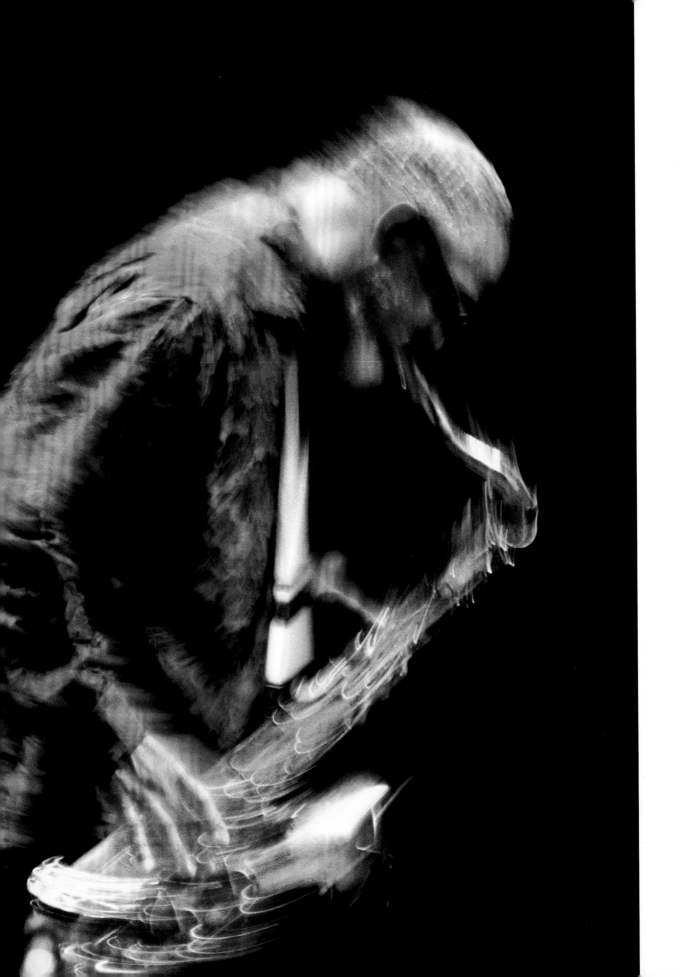

It begins with rhythm, whether we are talking about Sonny Rollins' most iconic album or his music in general. Listen to "St. Thomas," the opening track of his 1956 masterpiece *Saxophone Colossus,* and the first thing one hears is not the sound of the Rollins tenor sax, but sixteen bars of Max Roach's infectious, Caribbean-flavored drums. After Rollins states the traditional calypso theme, he pulls and tugs at the pulse, accenting percussively when not flowing over or against the support of Roach, pianist Tommy Flanagan, and bassist Doug Watkins. After a drum solo, when the rhythm section adopts a more straight-ahead beat, Rollins continues to create kinetically, stretching a phrase like taffy one moment, hammering another idea home through repetition the next. Whether the tempo reflects the Virgin Islands where his mother was born or the Harlem of his own youth, the music that Rollins creates on "St. Thomas," and has created throughout his career, always swings with authority.

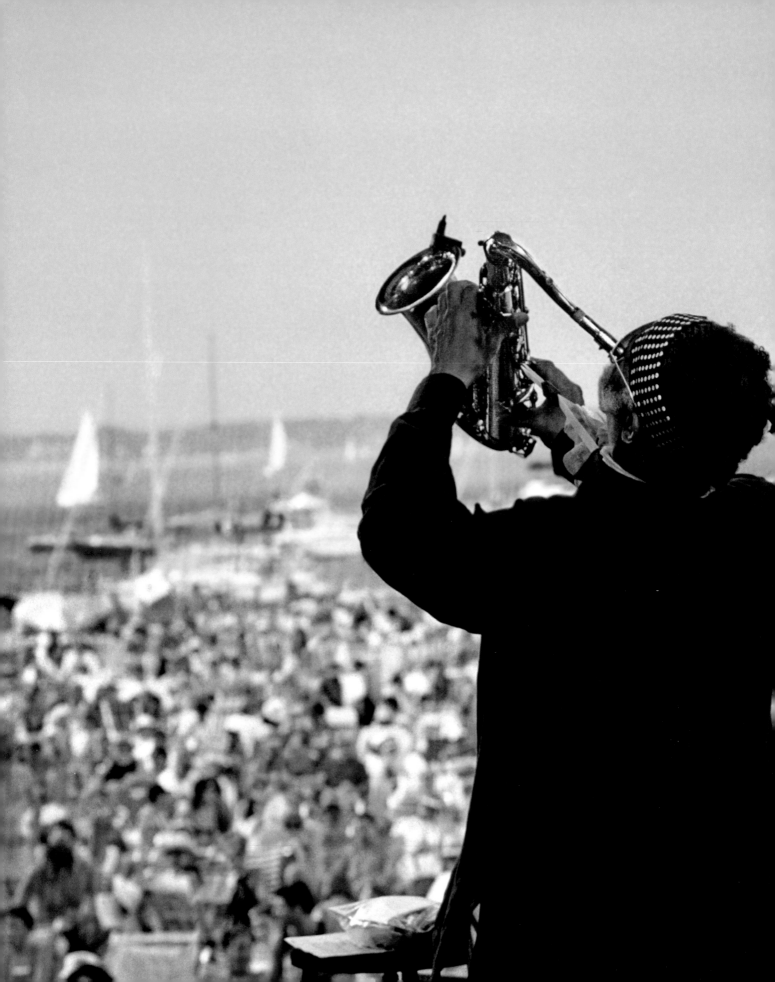

Exceptional strength and assertiveness in rhythmic realms had been Rollins' calling card from the time he began attracting the attention of fellow musicians. Miles Davis, who first heard the young saxophonist in 1948, reinforced the point when he began using Rollins on club dates and recording sessions. A more pensive and technically limited soloist than most of his generation, Davis recognized the value of musical contrast early on, and found that the aggressive Rollins style offered a perfect complement to his own solos. The difference, audible enough on such initial recorded collaborations from 1951 as "Whispering," "Out of the Blue," and "Dig," was reinforced when heard after the performances that Davis had recorded in the previous two years with a nine-piece band. The impressionistic mood of those latter tracks (with French horn and tuba in the tightly voiced ensemble) had launched a so-called cool movement. While highly influential from the outset, especially among musicians based in Los Angeles, Davis' "Birth of the Cool" nonet had generated significant controversy among listeners in the African-American community. Having a more intense saxophonist aboard on the small-group recordings that followed provided reassurance that Davis' music had not lost its edge. Rollins, barely out of his teens, was already being hailed by many as the harbinger of a contrasting style that had soon gained its own nickname: "hard bop."

Rarely in jazz history has someone so young become identified as an influence so quickly. Yet Rollins' searing, hard-swinging approach was a natural outgrowth of the sounds of musicians who influenced him as a youngster and those he was fortunate enough to play alongside as a young professional.

By his own admission, Rollins' first musical memories involve hearing the music of Thomas "Fats" Waller, whom he credits for "lay[ing] the groundwork for everything that followed." While the up-front humor in Waller's vocals and his ability to turn the most unpromising material into improvisational silk purses clearly left a mark on Rollins as well, the impact of Waller's piano solos may have had the greatest significance on the saxophonist's development. Waller, an acknowledged master of the two-handed stride piano style and a paragon of swing before the term became identified with big bands, built his infectious recordings directly from his instrumental approach. The six-piece band that Waller led so successfully in the final decade of his life was not known as a sextet, but rather as Fats Waller and His Rhythm.

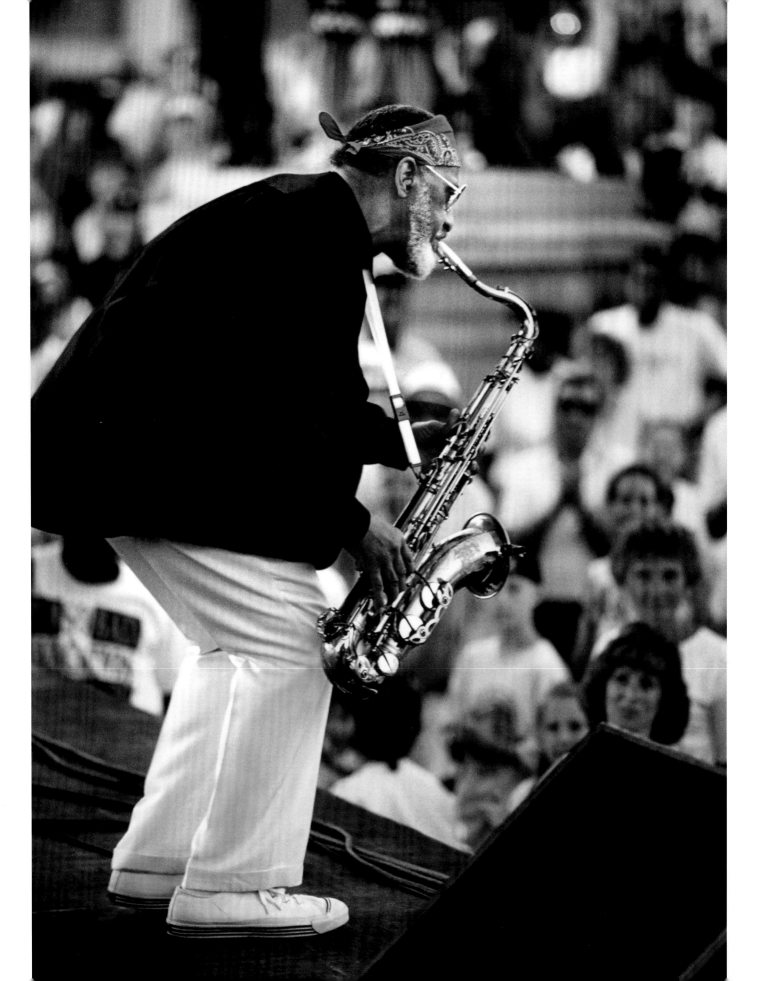

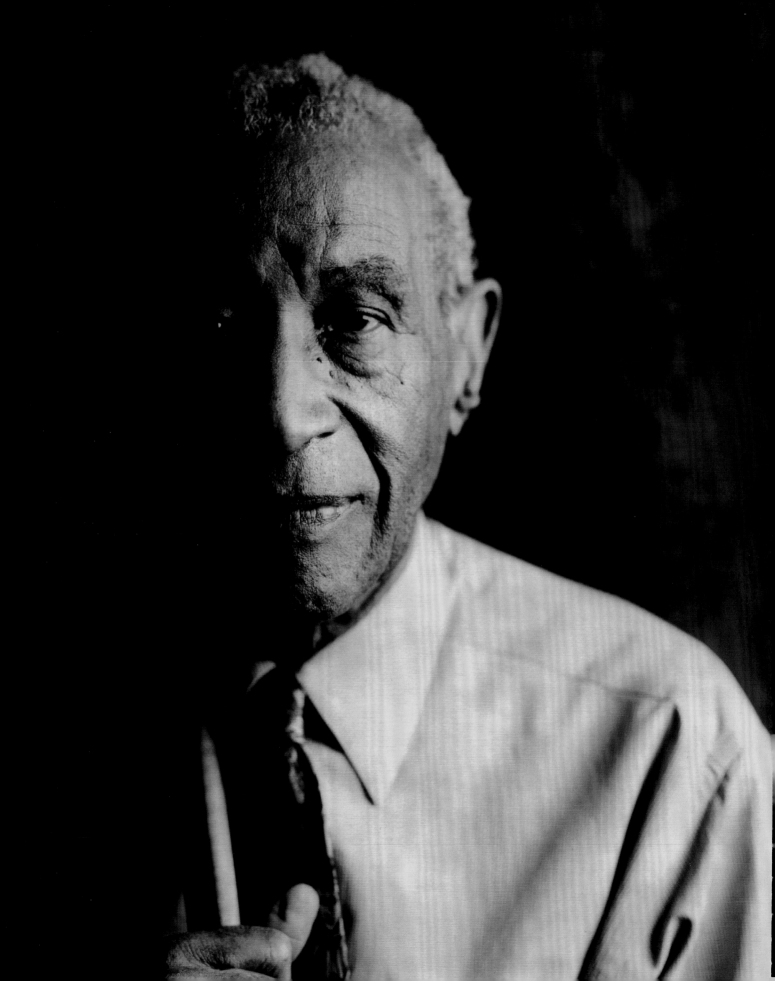

Other influences shaped Rollins' rhythmic approach as well. Coleman Hawkins, music's first great tenor saxophonist and Rollins' lifelong idol, was already a model for muscular extroversion at the time of Rollins' birth and would gain still greater stature in that regard after returning from a European sojourn in 1939. The innovations of alto saxophonist Charlie Parker revealed new and more complex ways to attack the beat, and shaped the concept of virtually every young jazz artist who came of age in the 1940s. Rollins also had the good fortune while still in high school to attend rehearsals at the home of Thelonious Monk, and he absorbed the pianist's complex melodic shapes and daring use of space well in advance of most of his contemporaries. The influence of Hawkins, Parker, and Monk can be heard from the moment Rollins began his recording career in 1949.

It also helped Rollins tremendously to be at the center of jazz activity at a time when a cohort of brilliant drummers was learning from the same masters. The modern jazz movement that Parker and trumpeter Dizzy Gillespie spearheaded demanded new levels of percussive complexity, and a number of drummers with startling technique and open ears rose to the challenge. Every one of them would become early and ongoing collaborators with Rollins. Kenny Clarke, acknowledged as the father of modern drumming and an original member of the Modern Jazz Quartet, was present when Rollins recorded his infectious original "The Stopper" (a reference to the melody's erratic "stop-time" rhythms) with the MJQ in 1953, as well as on the Miles Davis session that introduced the classic Rollins compositions "Airegin," "Oleo," and "Doxy" a year later. Art Blakey, whose volcanic approach drew most directly on African sources and played a role second to none in popularizing the hard bop style, was on the Miles Davis date that produced "Dig," as well as Rollins' own first recording session as a leader. Roy Haynes, Rollins' senior by five years and the lone surviving member of this astonishing generation of percussion talents, is heard behind Rollins on the exceptional titles of Bud Powell's Modernists (made a month before Rollins' nineteenth birthday) and on the Miles Davis session seventeen months later that yielded "I Know," the performance that led to the saxophonist's recording contract with Prestige.

Max Roach,
March 2002

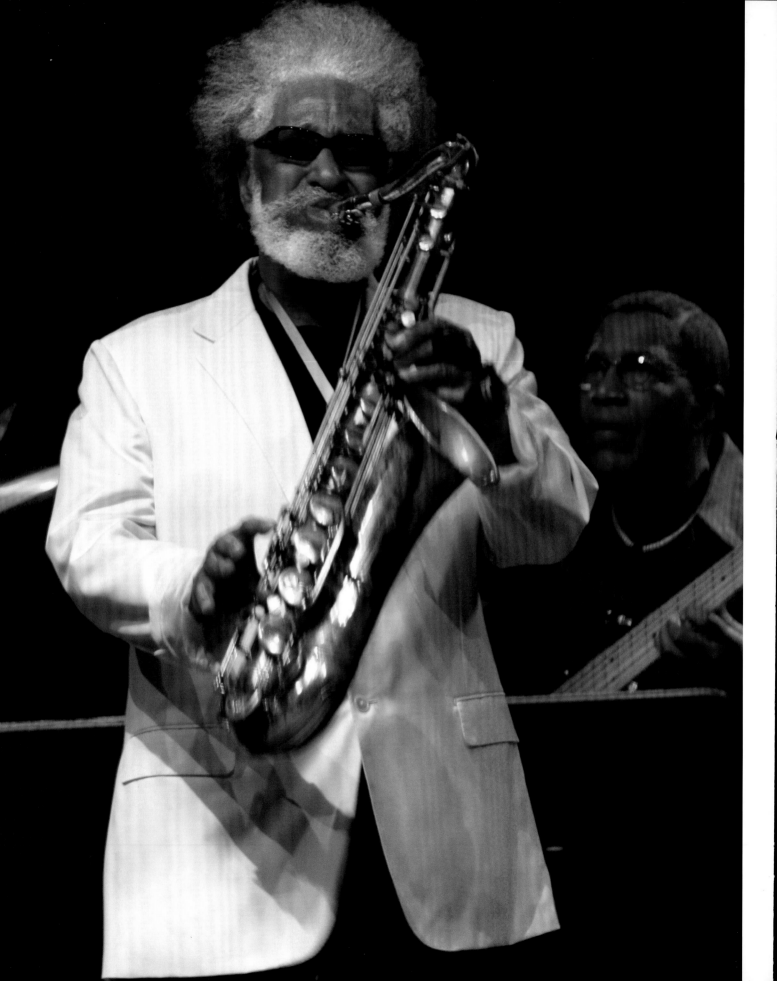

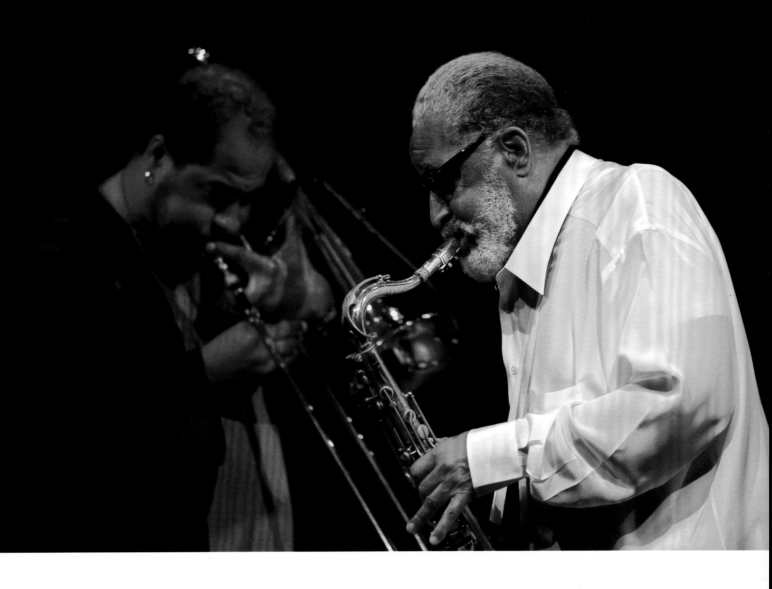

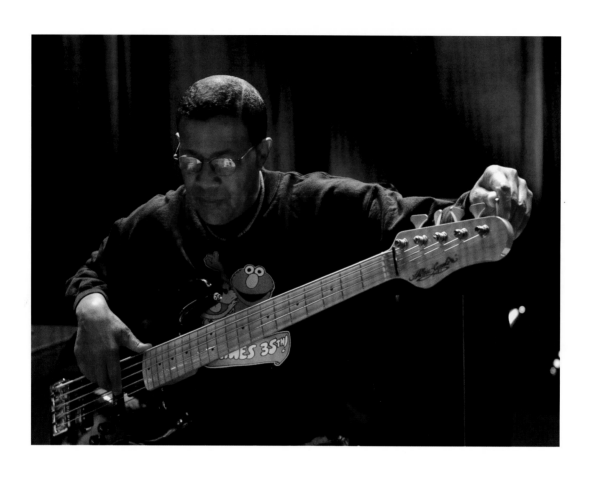

(ABOVE)
Bob Cranshaw, Frankfurt,
November 2008

(RIGHT)
Bobby Broom and Sonny Rollins,
Frankfurt, November 2008

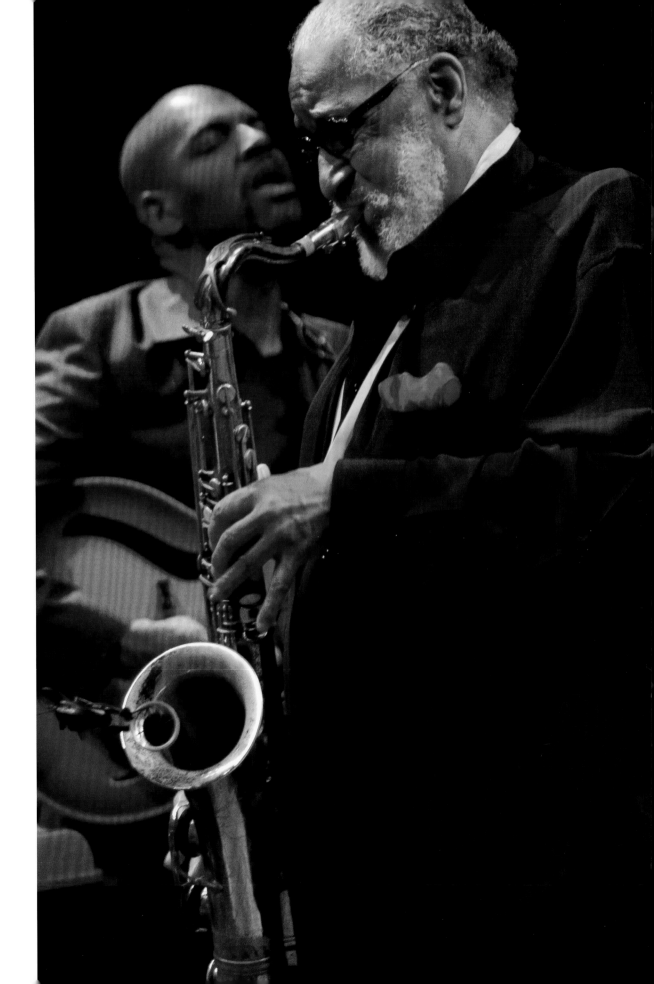

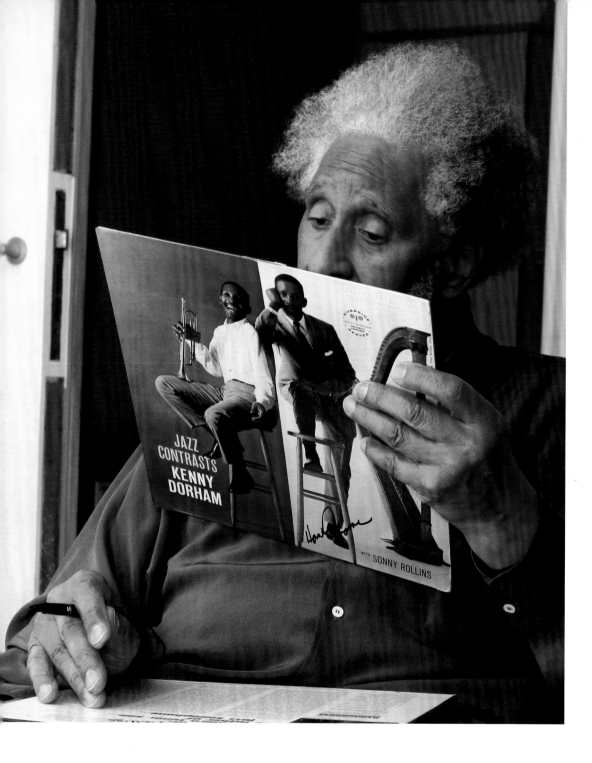

Dressing room after Berlin concert, December 2008

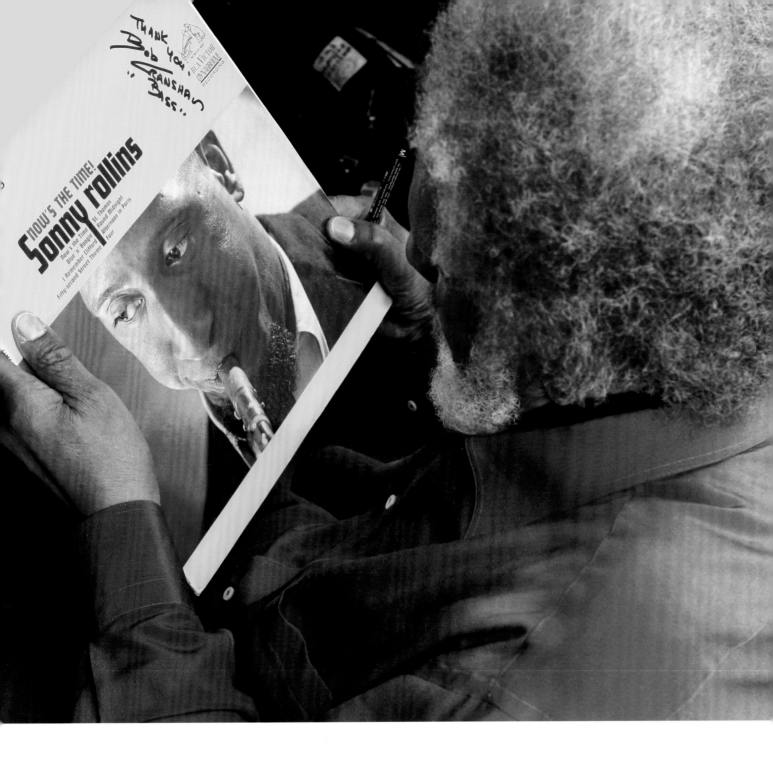

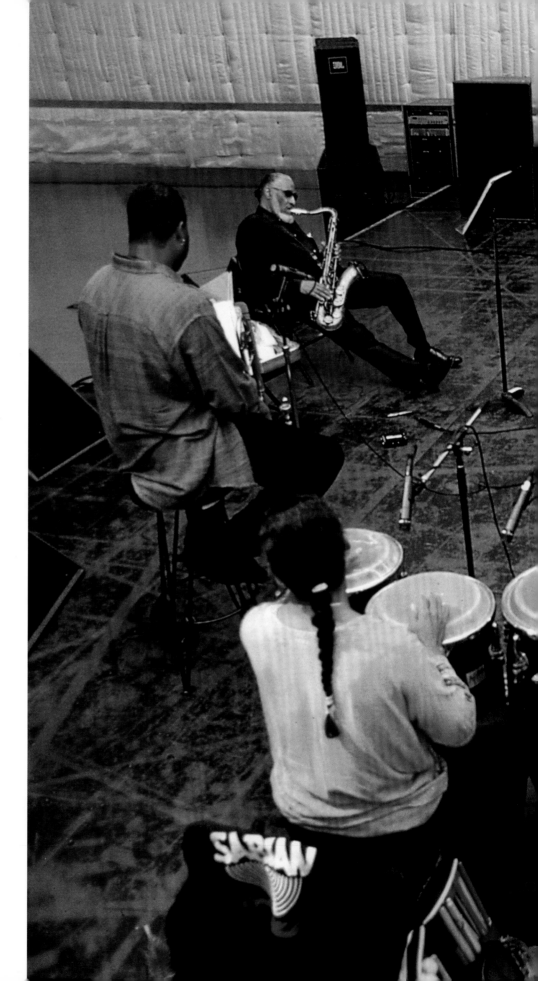

(LEFT TO RIGHT)
Clifton Anderson,
Sonny Rollins,
Victor Y. See Yuen,
Stephen Scott,
Bob Cranshaw,
Perry Wilson,
band rehearsal,
September 1998

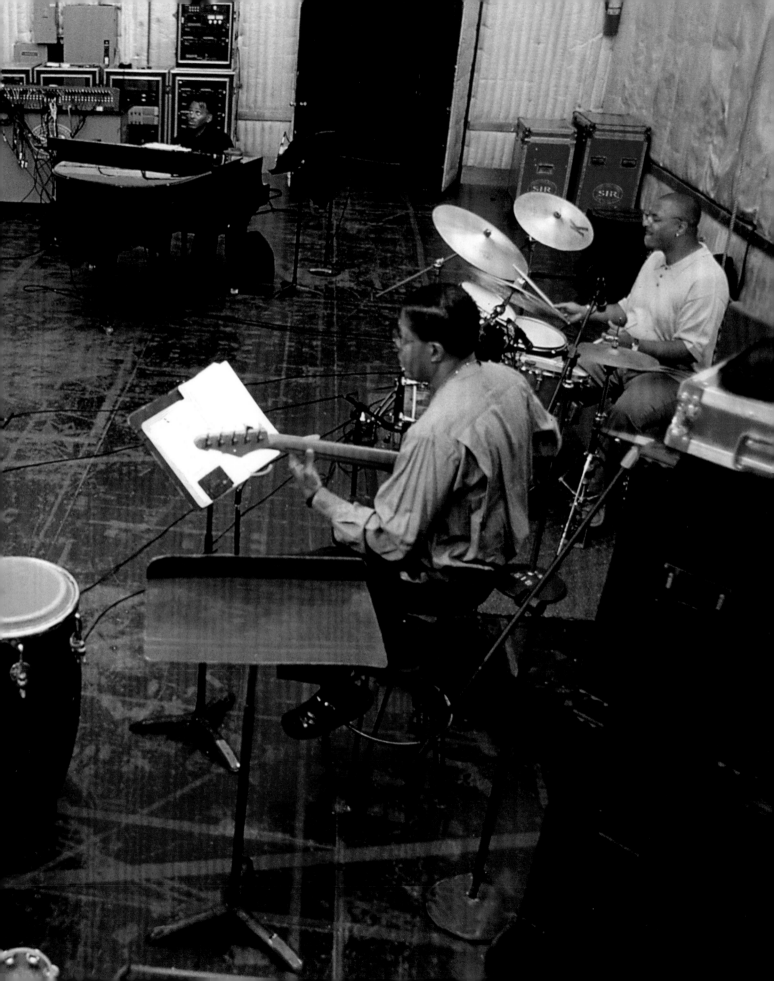

As Rollins' career progressed, none of these drummers proved more important to his development than Max Roach, whose beat enlivens "St. Thomas" and the rest of *Saxophone Colossus*. Roach had been present on Charlie Parker's first great recordings from 1945, and was the drummer in Parker's working groups between 1947 and 1949. His early encounters with Rollins were minimal, confined on record to a 1949 session under the leadership of trombonist J. J. Johnson; but in 1955, when Roach and trumpeter Clifford Brown found the saxophone chair vacant in their successful quintet, it was Rollins who got the job. For the next two years, Rollins made the vast majority of his appearances in person and on record with Roach in the rhythm section. The pair shared a love of fast tempos, best exemplified by the supercharged "B. Swift" and "B. Quick," and a fascination for waltzes at a time when virtually all jazz was played in 4/4 tempo, as first expressed on the Rollins composition "Valse Hot." As a soloist, Roach placed his admirable technique in the service of the most melodic of percussive concepts, and as an accompanist he possessed both the stamina to enhance extended improvisations and the flexibility to articulate the widest range of moods. In both featured and supporting roles, he focused on the overall shape of a performance with a single-mindedness rare in musicians on any instrument. All of these qualities proved essential to the success of Roach's partnership with Rollins, and the drummer's empathy and stylistic breadth, obvious throughout *Saxophone Colossus*, are on particular display in its opening track.

"St. Thomas," erroneously credited by Prestige Records as an original Rollins composition, is in fact one of the most familiar of traditional calypso melodies. As is the case with several other tunes that later entered the Rollins repertoire, it is a remembrance of familial roots. His great-grandfather was from Haiti, and his mother, who hailed from the Virgin Islands, would bring her young son to dances and other functions where island music was performed. The connection was not unique among musicians of the period (two of Rollins' boyhood friends, pianist Kenny Drew and drummer Arthur Taylor, also had family ties to the West Indies), and others had added Caribbean flavor to jazz in the past (as when soprano saxophonist Sidney Bechet and pianist Willie "The Lion" Smith recorded several traditional titles with a quintet called the Haitian Orchestra). In any event, at least a nodding familiarity with a variety of ethnic musics was something of a necessity for musicians who, given the various immigrant communities in

urban centers and the economic vagaries of the jazz life, might find themselves playing anything from bar mitzvahs to polka gigs. "I never played in calypso bands," Rollins has noted, "but the jobs I began taking as a young musician required that I be able to play calypso."

Musicians were also expected to respond to commercial trends. The growing popularity of the mambo at the time of Rollins' first session as a leader led him to record the original "Mambo Bounce" for inclusion in an anthology called *Mambo Jazz*. The success of Harry Belafonte's million-selling *Calypso* album at the time *Saxophone Colossus* was recorded must have led Rollins' record label to consider "St. Thomas" a similarly audience-savvy choice. Yet where "Mambo Bounce" was clearly nodding to a fad, with Art Blakey quickly abandoning the Afro-Cuban beat once Rollins launched his saxophone solo, "St. Thomas" is a coherent integration of calypso and jazz, with the entire rhythm section sustaining the island feeling during the first tenor solo and Rollins, Roach, and pianist Tommy Flanagan all finding ways to flavor their improvisations with phrasing that would sound natural over a steel drum ensemble. "St. Thomas" succeeds so brilliantly because it is not a gimmick, but rather a sincere expression of the range of Rollins' rhythmic ideas.

It is all the more surprising, then, that Rollins proceeded so cautiously in exploring what might be called the Caribbean tinge in his music. In the two years that followed *Saxophone Colossus*, which mark his most active phase as a recording artist, he would assay an entire album of waltzes with Roach, any number of Tin Pan Alley obscurities, and even a few songs identified with cowboys, but only one additional calypso: the pop song "Mangoes." Between 1962 and 1964, when Rollins was under contract to RCA Victor and produced a number of his most important performances, the label attempted to ride the bossa nova wave with the album *What's New*, which only glanced at samba rhythms on two standards while proving most memorable for Rollins' encounter with the Cuban percussionist Candido Camera on the blues-based "Bluesongo" and free-form "Jungoso." Among the tracks recorded as part of this project were two calypso titles on which the working Rollins quartet was joined by three added percussionists and six background vocalists, yet one of these, "Don't Stop the Carnival," was issued only on the European edition of the album. In one of the great ironies of his career, this first recording of a song that would become as much of a Rollins trademark as any in his repertoire, would have to wait three decades before its first U.S. release.

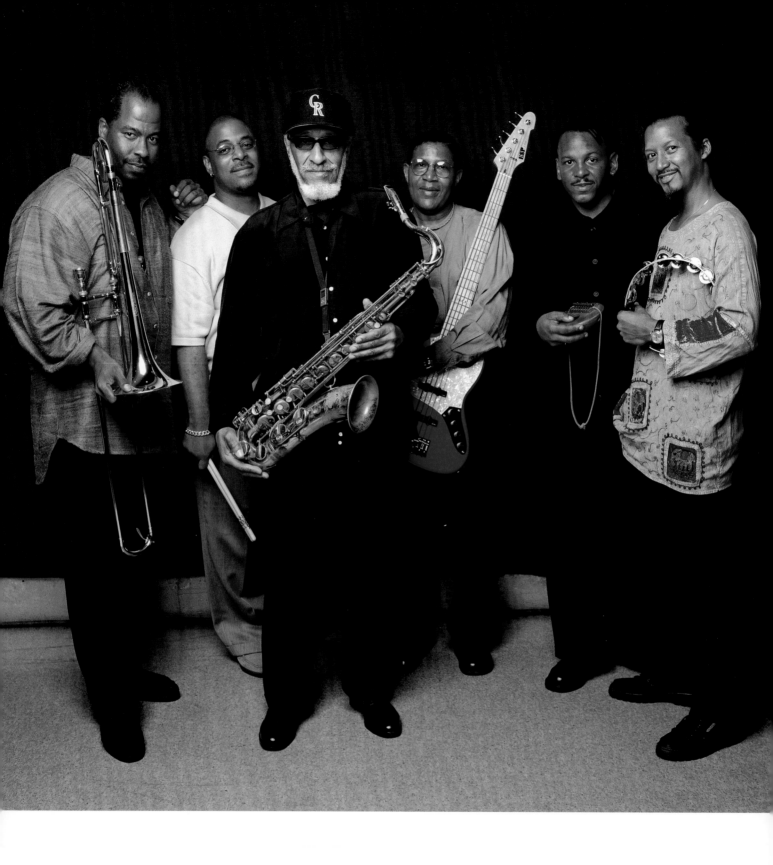

Rollins did not abandon calypso entirely as he approached what would become an extended absence from public performance between 1968 and 1972, but the island beat was clearly not a priority. When he assembled *Now's the Time,* a collection of jazz standards, he chose "St. Thomas" as representative of his own work, and the ensuing performance referenced the original version with a fealty uncommon in the Rollins discography. Another West Indian warhorse, "Hold 'Em Joe," was included on a 1965 recording, but when Rollins withdrew from music two years later, it appeared to be his final statement in the idiom.

Rollins returned to music in 1972, and he had clearly reconsidered his feelings about both calypso music and rhythmic accompaniment. His initial studio recording after this lengthy sabbatical included the first of what would be several truly original compositions in the idiom, "The Everywhere Calypso," with a second percussionist reinforcing the drums. Others followed in the ensuing decades, several of which ("Island Lady," "Coconut Bread," "Mava Mava," "Duke of Iron," "Global Warming") have at one time or another become a standard part of Rollins' live performances.

No single song became more identified with Rollins in the past three decades, however, than "Don't Stop the Carnival." A pair of live versions from 1978—one with a modified version of his working band, the other from the Milestone Jazzstars tour that also featured pianist McCoy Tyner and bassist Ron Carter—captures Rollins the calypsonian at his most bacchanalian and introspective, respectively. Over time, passion has prevailed, and the concise melody and repetitive harmonies of "Carnival" have allowed Rollins to test the sonic extremes of his instrument while his phrases flow spontaneously from pretzel-shaped torrents to a single-note insistence that suggests nothing so much as a wind-driven percussionist. Rollins' move from nightclub venues to concert halls and outdoor performance spaces in the past quarter-century may have played its part as well, as these less intimate, more poplike environments seem to generate the celebratory spirit that calypso music engenders.

Which does not mean that Rollins has abandoned other ways of displaying his command of the beat. Straight-ahead jazz tempos have remained constant, while other notions have also surfaced from time to time. If his excursions into pop music realms have met with less success, there are originals such as "Harlem Boys" that manage to deliver both hooks and substance. More recently, Rollins has cited the influence of Native American music on one of his compositions, "Sonny, Please." To paraphrase a Jimmie Lunceford hit from the dawn of the swing era, rhythm remains Sonny Rollins' business.

It also remains something of an obsession when one considers the odd blend of consistency and flux that marks the history of the working Rollins band. Bob Cranshaw, whom Rollins first met in Chicago in 1959, has been his bassist of choice since 1962, a reliable presence who holds down the musical foundation with unshakable time, an effortless sense of harmonic flow, and few of the virtuosic displays that mark the approach of most younger bassists. Trombonist Clifton Anderson, the son of Rollins' late sister, Gloria, has also been a constant since 1984, a testament to the saxophonist's love of the tenor/trombone blend that harks back to his early recordings with J. J. Johnson and Anderson's own family connection to Caribbean rhythms. While Rollins' preference for piano and/or guitar has fluctuated over time, his sidemen on each instrument have been fairly constant, with Stephen Scott serving as pianist for most of the 1990s, supplanted by guitarist Bobby Broom in recent years. When it comes to drummers, however, personnel seems to be in constant flux, a situation compounded by the need for Rollins' drummer to blend with the second percussionist that the saxophonist has made a part of his working band for nearly a quarter-century.

Many of the most acclaimed drummers in jazz have worked with Rollins at one time or another since he recorded *Saxophone Colossus.* The list includes such luminaries as Philly Joe Jones, Shelly Manne, Elvin Jones, Ben Riley, Billy Higgins, Jack DeJohnette, Tony Williams, Al Foster, and Marvin "Smitty" Smith. Few, though, have developed any longevity in their relationship, and none has created the sustained body of music with the saxophonist that Rollins and Roach were in the midst of generating when they recorded *Saxophone Colossus.* "I had a certain sound I wanted to get," Rollins has said of his early frustrations as a bandleader, "and I can see why some musicians from that time might hate me—I'd hire them for one night, then get somebody else a night later." If his more recent experience has hardly been as extreme, when it comes to drummers Rollins is still searching for that certain sound.

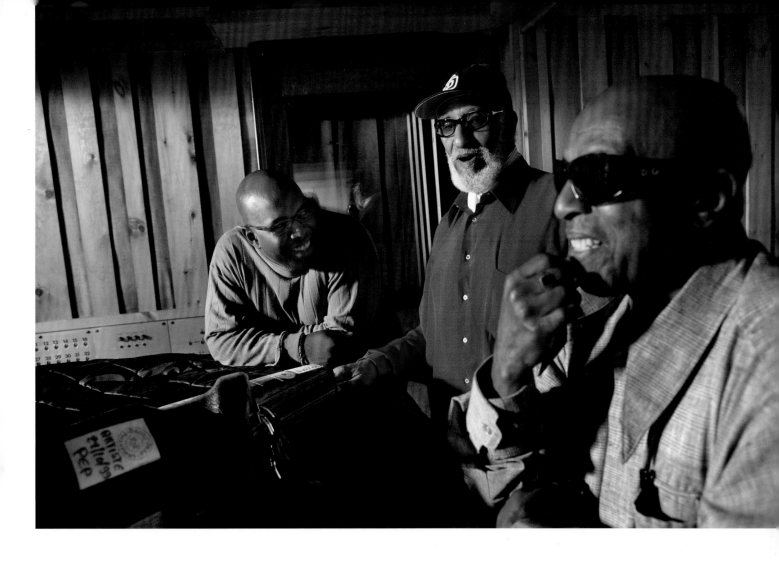

Christian McBride, Sonny,
Roy Haynes, September 2007

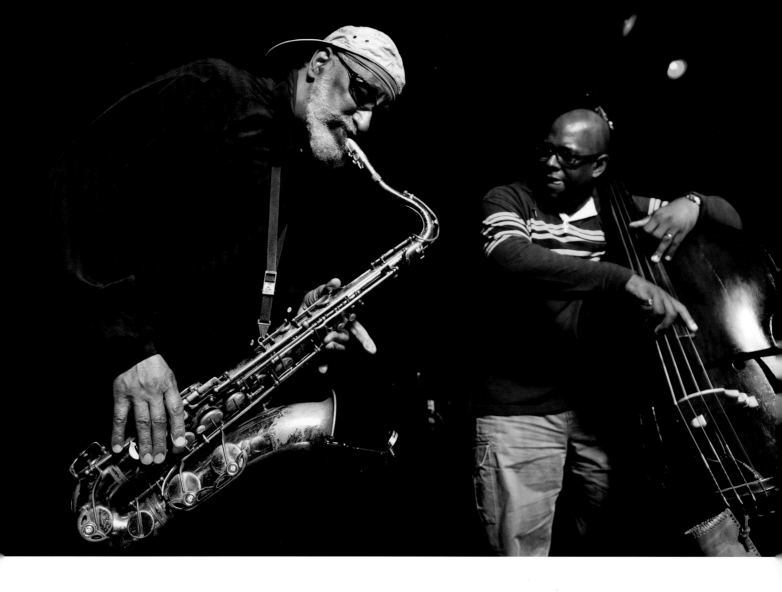

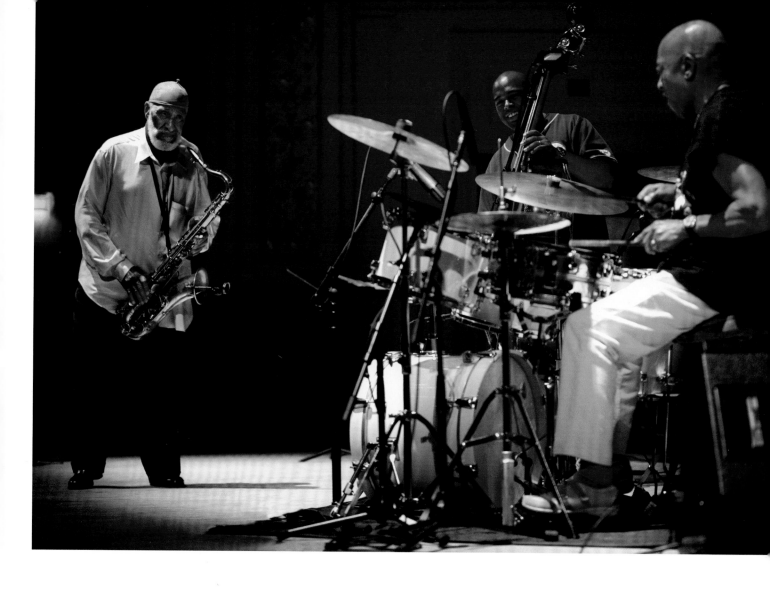

(ABOVE LEFT)
Sonny and Christian McBride,
September 2007

(ABOVE RIGHT)
Carnegie Hall sound check,
September 2007

37

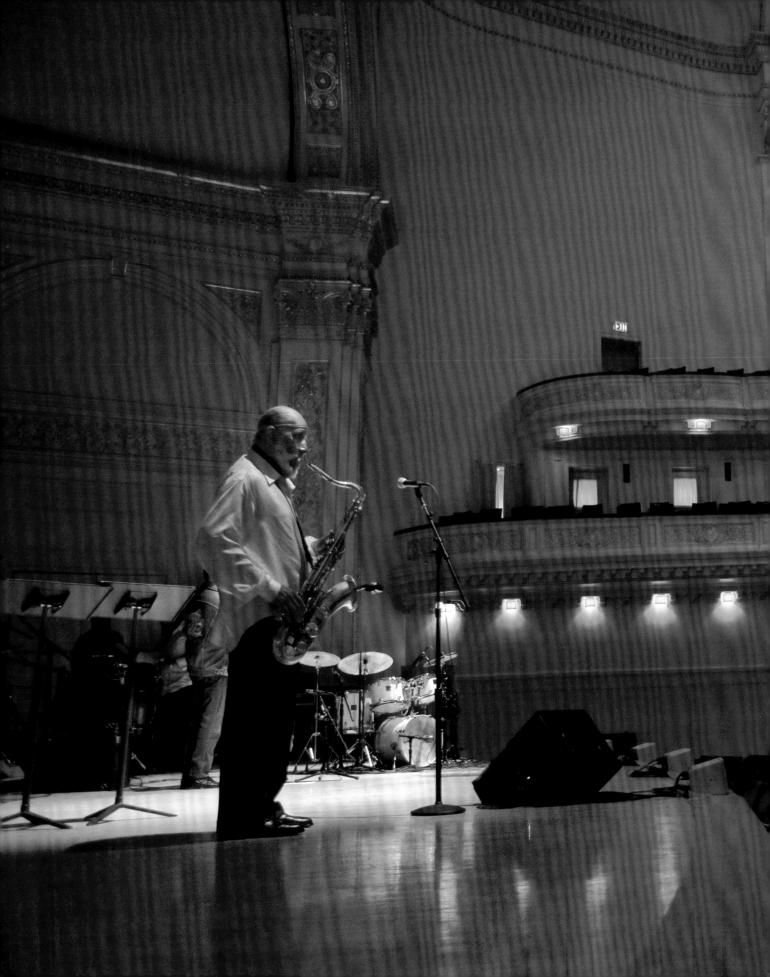

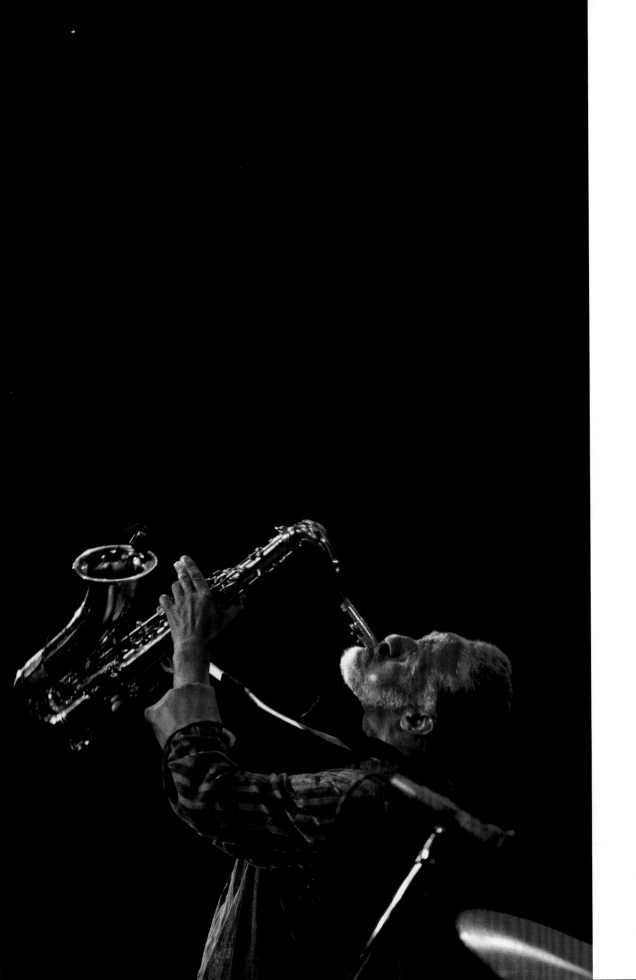

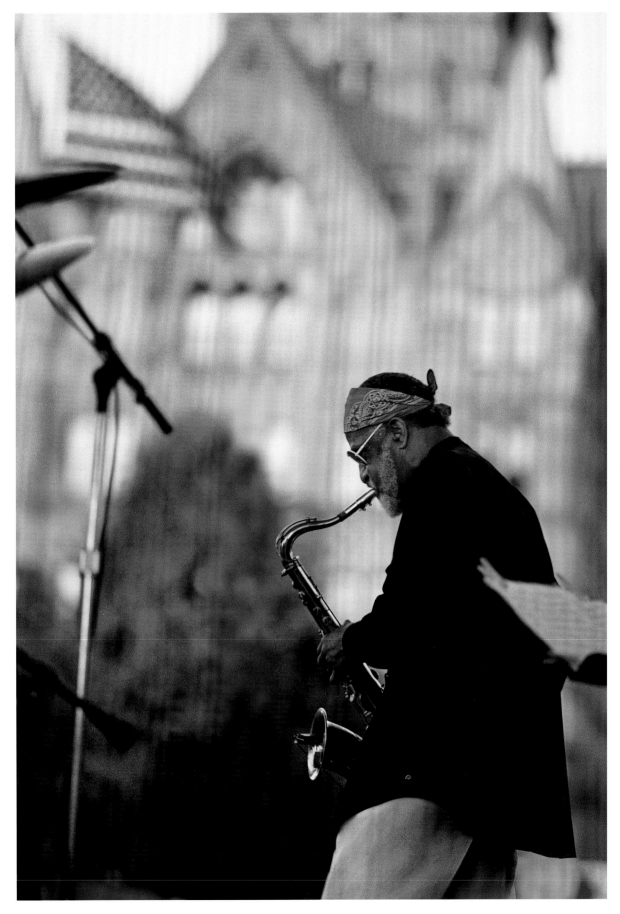

YOU DON'T KNOW WHAT *LOVE* IS

SONNY'S SOUND

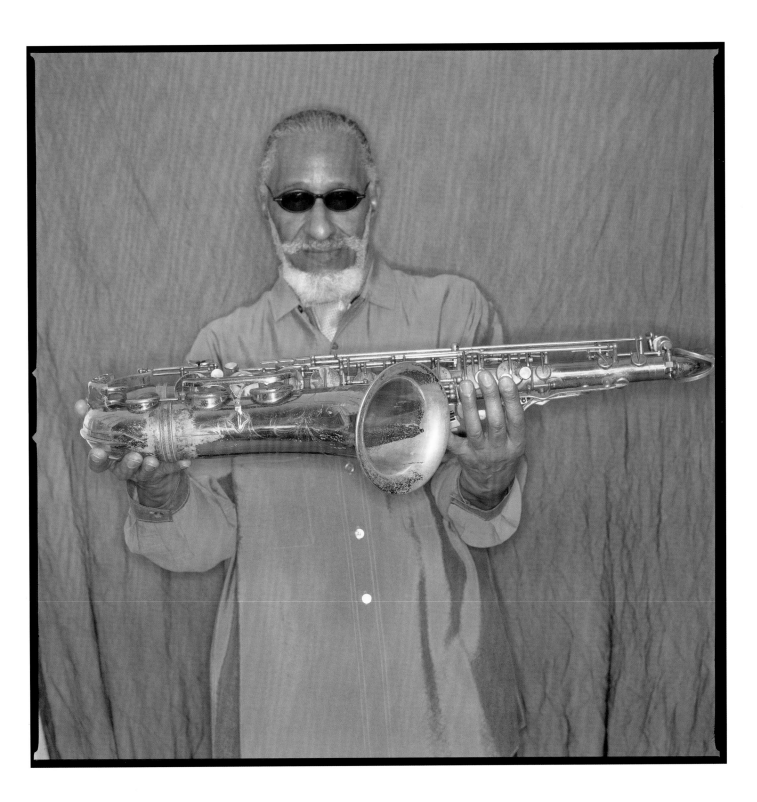

Prestige Records may have seemed presumptuous in dubbing Sonny Rollins a colossus at the age of twenty-five, but the image of a tenor saxophonist as looming presence in the jazz world was hardly far-fetched. After the trumpet, which as Louis Armstrong's horn gained pride of place as the music's first iconic instrument, the tenor sax had long been a focal point of interest, innovation, and excellence. Tenor players were dominant voices in almost every major ensemble, and notwithstanding the aura of Armstrong's trumpet, Benny Goodman's clarinet, and Charlie Parker's alto sax, the tenor was well on its way to becoming jazz's signature sound when Rollins first gained notice. His ongoing maturity had much to do with this transition, yet he was hardly the only giant on the block.

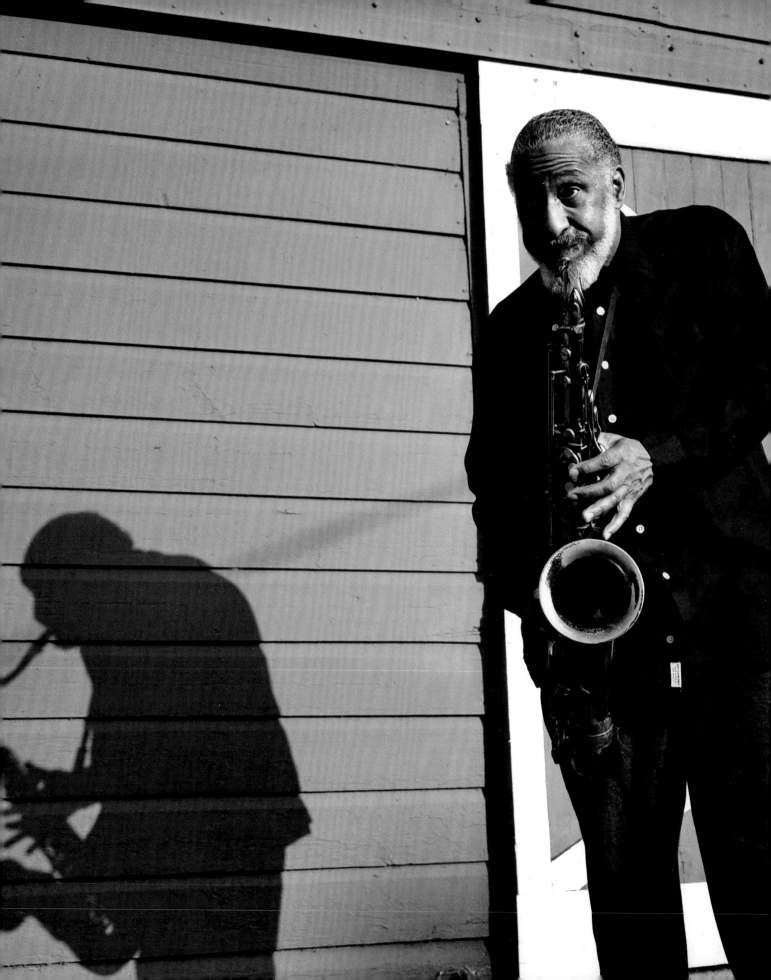

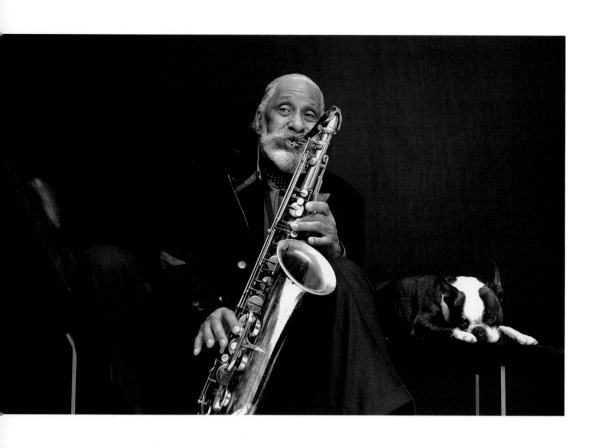

(ABOVE)
Sonny and "Dizzy,"
New York, May 2005

(RIGHT)
Sonny's studio at his home in
Germantown, N.Y., August 1995

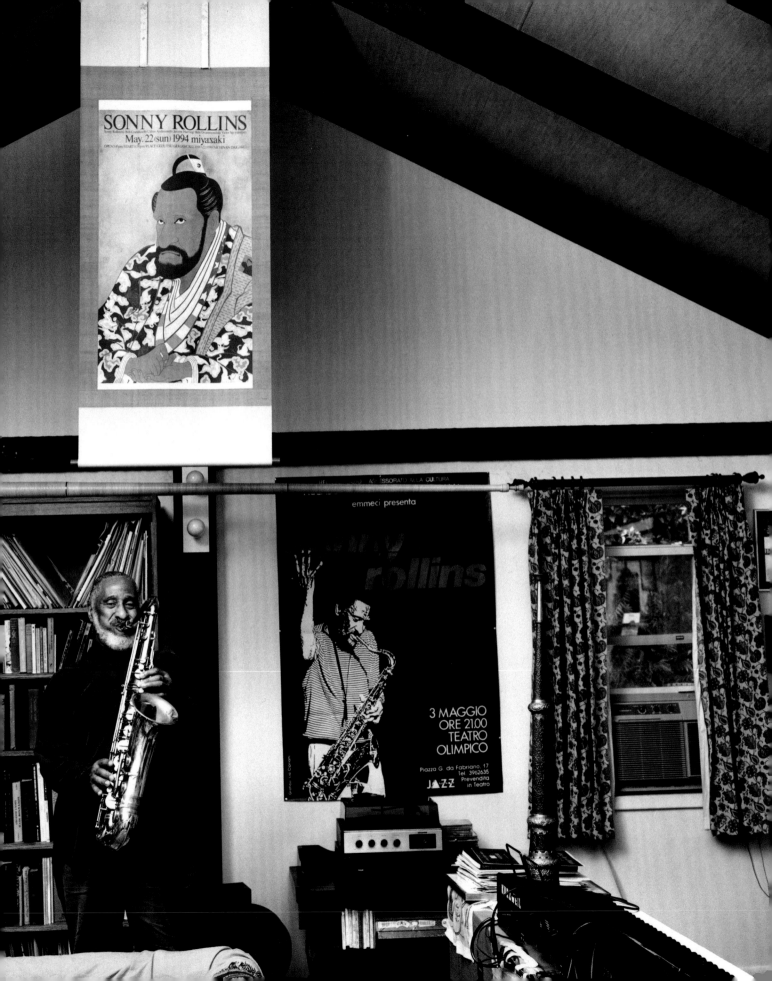

No tenor saxophonist loomed larger than the horn's patriarch and Rollins' acknowledged idol, Coleman Hawkins. Hawkins had joined the Fletcher Henderson Orchestra in 1923 where, inspired by the fleeting presence of Armstrong a year later, he transformed himself from a proficient technician known for vaudeville effects to an improviser with a rhythmic flair exceeded by that of only Armstrong himself and a harmonic daring second to none. By the time Hawkins left Henderson in 1934, he was considered the definitive big band sideman and featured soloist. Hawkins' profile was eclipsed in America over the next five years while he sought more creative opportunities and less overt racism in Europe, but he quickly reasserted himself upon returning to New York in 1939 with his immortal recording of "Body and Soul." As both the first jazz star to present himself without showbiz trappings in small-band settings, and the most prominent established figure to endorse modern jazz and hire many of its best young practitioners, Hawkins also ensured ongoing respect and continued relevance at a time when stylistic changes were more likely to promote antagonism across musical generations.

Rollins was a ten-year-old who had recently picked up the alto sax when he first heard "Body and Soul" and immediately concluded that he was playing the wrong instrument. His hero worship grew after he switched horns and learned more music, fueled by opportunities that Harlem afforded to observe Hawkins both at work (on the Apollo Theater stage if not the bars that were off-limits to teenagers) and as a celebrated local resident. Rollins once showed up at the King Haven apartments where Hawkins lived and obtained an autograph on the photo he had in his scrapbook. Another sighting took place during one of Rollins' weekly visits to the Loew's Theater. "There was Coleman, who came in and sat down in the front row," Rollins recalled decades later. "I'd go blind sitting in the front row, but that's where Coleman liked to sit."

Other established tenor saxophonists left their mark on Rollins, including such earlier Hawkins acolytes as Ben Webster and Don Byas, as well as Lester Young, whose lighter tone and elliptical phrasing had first provided an alternative model for playing the horn during Hawkins' European absence. By the late 1940s, Young had become the more prominent role model for young saxophone players, not to mention a seminal hipster whose speech was as sui generis as his music and provided a healthy portion of Beat Generation

vernacular. Rollins absorbed Young's musical concepts as well, yet remained a Hawkins man, taking inspiration from his idol's music as well as his image.

In discussing Hawkins, Rollins identifies him as "the guy who was out there, just playing a horn, that was it. Louis [Armstrong] was setting the pace, too; but Louis also sang and entertained. Coleman really set the whole thing as we know it today in motion." So the very format of *Saxophone Colossus,* minus vocalists, novelty numbers, or commercial concessions of any kind, bears the imprint of Hawkins, a connection that is most pronounced on the album's ballad track, "You Don't Know What Love Is."

Hawkins had made the jazz ballad feature his own as early as 1929, when he recorded "If I Could Be with You One Hour Tonight" with the Mound City Blue Blowers. For Rollins, this great Hawkins ballad performance and those that followed had both artistic and extramusical significance. "The thing that impressed me most about Coleman was how he always dressed well and carried himself with dignity. A black musician who displayed that kind of pride, and who had the accomplishments to back it up, was a refutation of the stereotypical images of how blacks were portrayed by the larger society." At the core of this dignity was Hawkins the ballad player. "His ballad mastery changed the conception of the 'hot' jazz player," Rollins continues. "He changed the minstrel image, if I may use a term that radical; he showed that a black jazz musician could depict all emotions with credibility, even a beautiful ballad that represented the peak of civilization."

The substance of Hawkins' ballad work also shaped the Rollins style. Harmonically, Hawkins led the way in superimposing more sophisticated and abstract chord sequences on a song's basic harmonic patterns, anticipating in the process countless sax players who followed in his wake as well as virtuosos on other instruments such as pianist Art Tatum and trumpeter Dizzy Gillespie. Hawkins' harmonic ideas reinforced the most authoritative of saxophone tones. "Coleman Hawkins had a gorgeous sound," Rollins emphasizes. "That's the first thing that grabs you, because sound is such a huge part of music. A person can be executing a lot of ideas; but if he doesn't have the sound to make them palatable to people, it doesn't make much difference. A guy with a sound and only a few ideas can go further than a guy with a lot of ideas and no sound. Not that he needed to hide anything, but Coleman's sound could have hidden a multitude of sins."

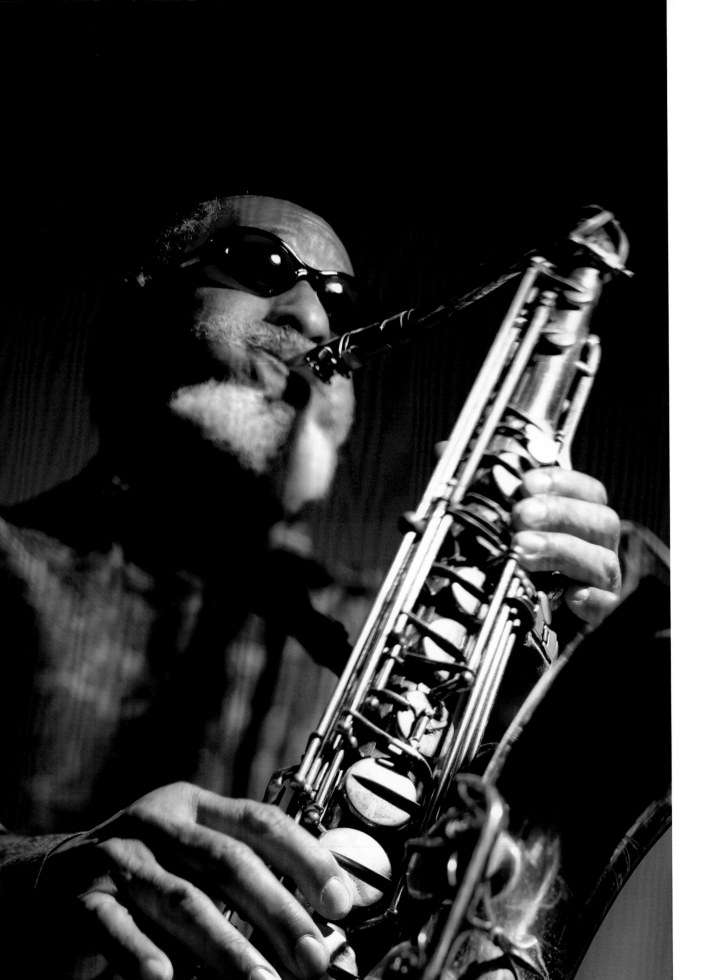

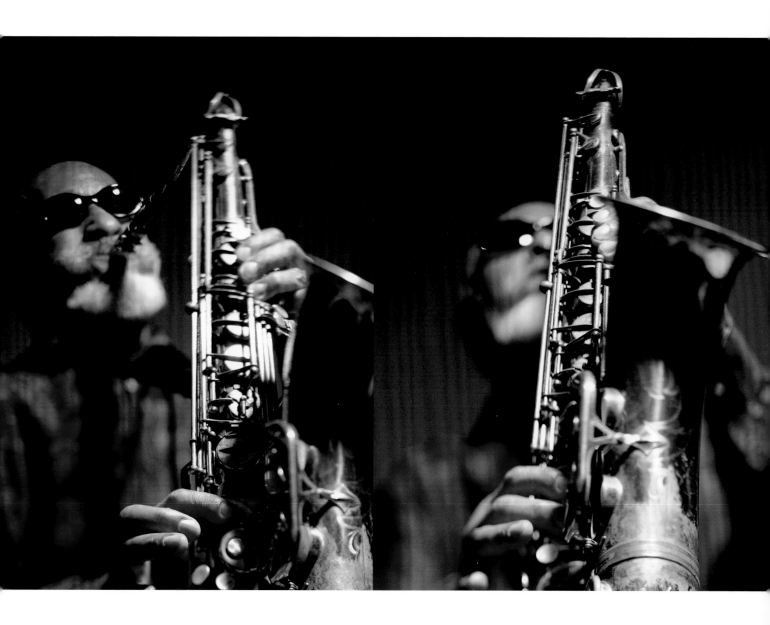

Rollins showed attentiveness to the Hawkins ballad concept from the outset of his own career, which also happened to be the point at which the new microgroove technology allowed for more sustained performances at slow tempos, but the unfinished nature of the Rollins sound created inconsistencies. He is impressive on the Miles Davis recording "Blue Room," moving from cautious paraphrase to snappish insistence in the space of 16 bars, yet reed problems and dissatisfaction with his instrument left audible signs of struggle that mar "My Old Flame," which Rollins recorded with Davis nine months later. Even on "Flame," though, there is an undeniable presence that gives focus to his interlude.

Further growth was spurred by the opportunity to rehearse and work with Thelonious Monk, the ultimate iconoclast, whom Hawkins had hired and given the opportunity to record well in advance of anyone else. On "More Than You Know," the first of three incredible ballads that Rollins recorded with Monk, the tenor sounds fuller and more controlled, with rough edges conveying expressive intent rather than deficient technique. The saxophone chorus, with variations generated by both the song's melody and Rollins' own ornamental flourishes, possesses a rhapsodic sweep made even more impressive by the uncommonly slow tempo. In other performances, his newfound instrumental control allowed Rollins to display a more subtle approach, as when he created the aura of a ballad on the medium-paced "When Your Lover Has Gone" by implying a slower tempo than that of his rhythm section.

Strength and directness are Rollins' trademarks, however, and the booming phrase that opens "You Don't Know What Love Is" announces a performance that presents a brilliant, muscular, and dramatically unruly romanticism. After stating the melody with gruff affection, Rollins turns combative in his improvisation, throwing flurries of notes against more measured phrases, hammering insistently at an oblique idea before implying a more decorous alternative, adding grainy textures or sprawling vibrato to his sound. The mood is engaged and somewhat ominous, and when the rhythm section doubles the tempo, Rollins takes the cue and brings his statement to a boil, but only after introducing momentary comic relief with a snatch of faux-Chinese music that might have migrated from the soundtrack of a Charlie Chan film. Tommy Flanagan, already a paragon of elegance at what was the start of his own recording career, provides respite in a gentle 16-bar piano solo; then Rollins returns for a final half-chorus, abandoning the melody for more complex variations and a final strophe that is more snorted than blown.

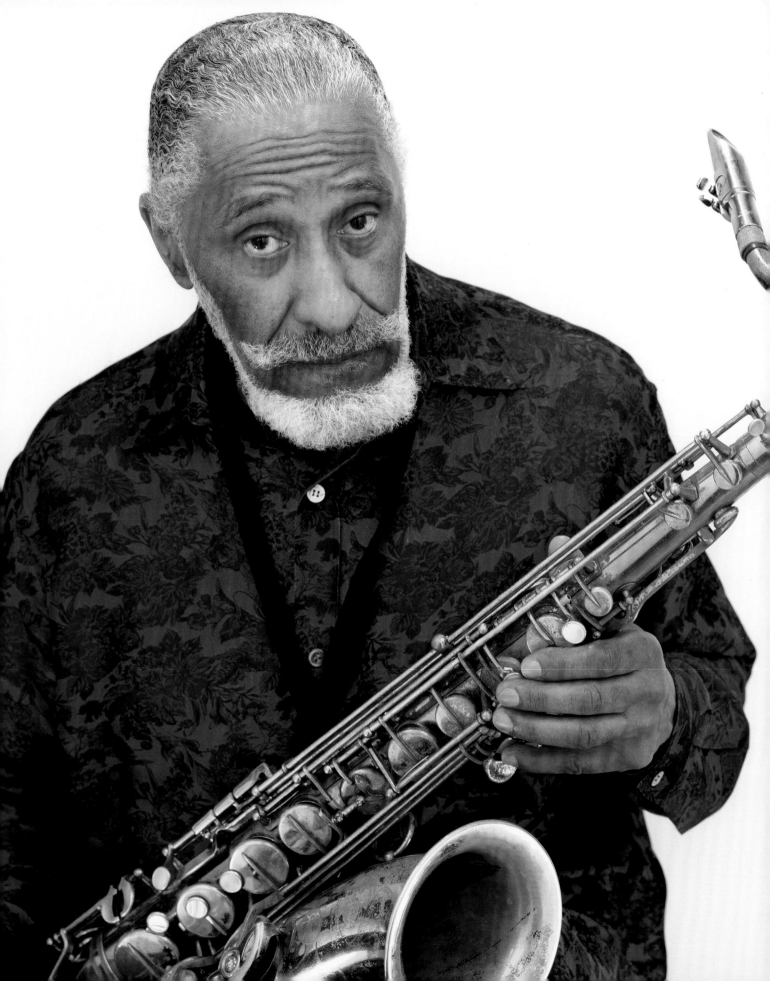

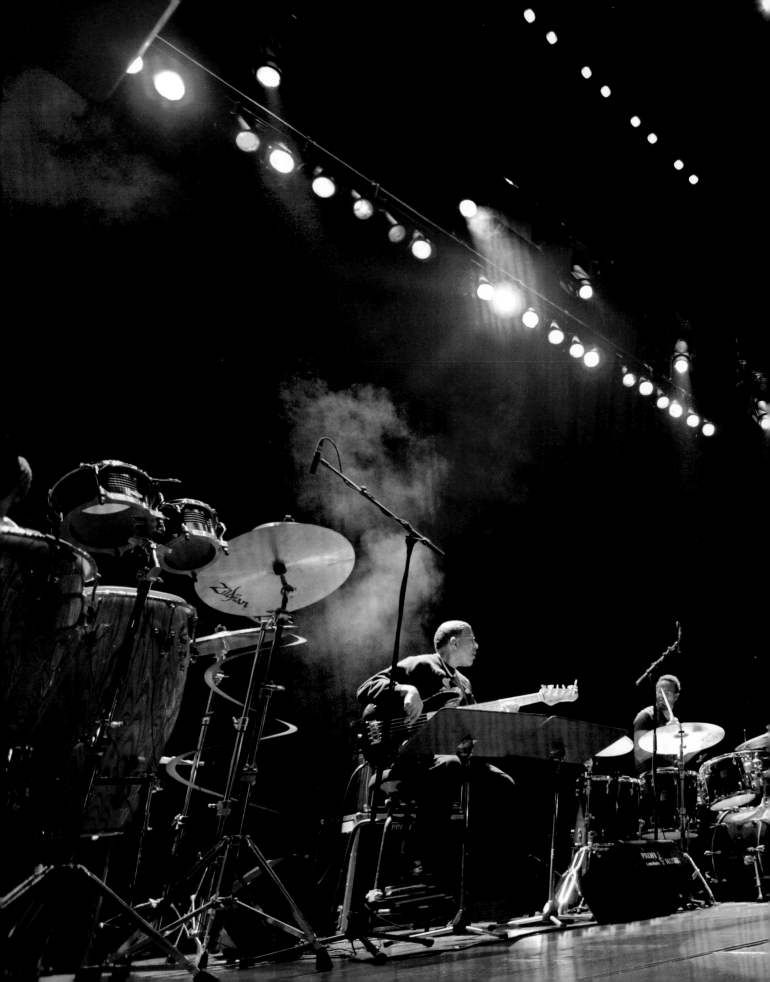

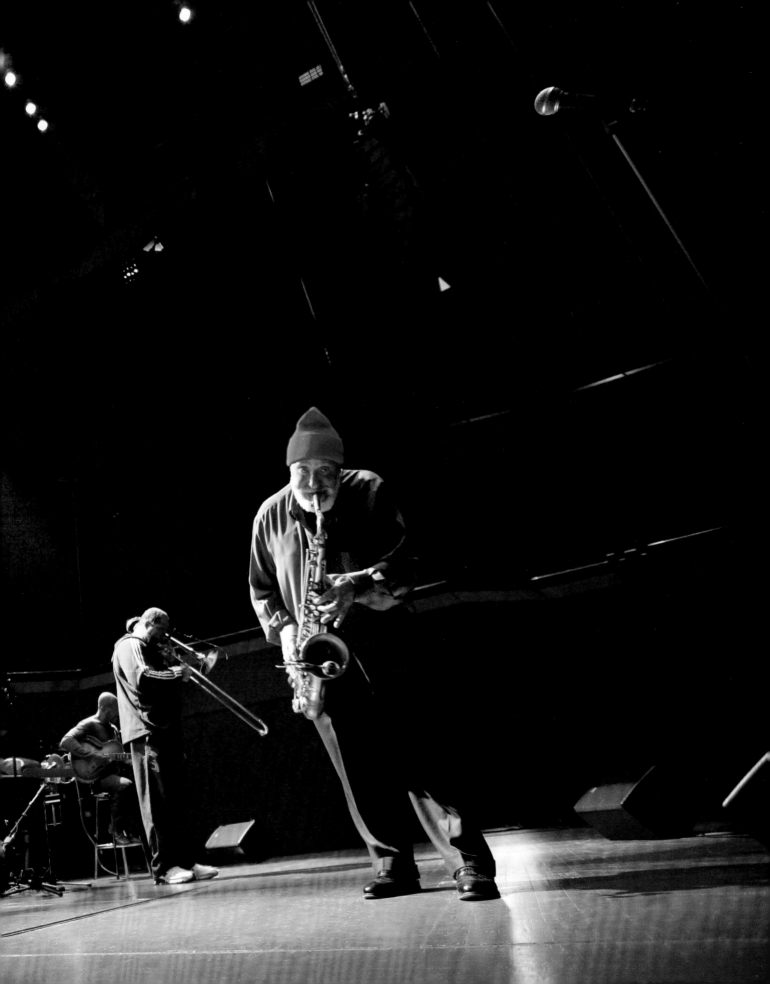

The Rollins style—warm but caustic, with the sonic heft and harmonic ambition of Hawkins plus a boldness and wit all its own—was now in place. In the period that separates *Saxophone Colossus* from his 1959–61 sabbatical, Rollins would record a wealth of exceptional ballads, with several of the best taped during the final months before he began working in clubs and concerts as the leader of his own band. "Pannonica," one of Monk's most haunting creations, contains a Rollins chorus in which his own resolutely linked melodic shards and brute-force exclamations hurtle against the support of Monk's chordal agitations. With Max Roach's drums doubling the original tempo while Oscar Pettiford's bass lines cut it in half, the overall effect is one of delectable tension. "There Is No Greater Love," from the first classic Rollins trio album, *Way Out West*, is a more tender reflection on the song's lyrics (which Rollins had read to bassist Ray Brown and drummer Shelly Manne in the recording studio), yet still with space for stop-time accents, quotes of familiar songs, and other, more belligerent insertions. "Reflections," the final ballad collaboration with Monk, is again in the stentorian mode, as saxophonist and pianist sustain a superhuman level of intensity. A return to "My Old Flame," this time under the leadership of trumpeter Kenny Dorham, features a half-chorus Rollins statement that balances reverie and outburst in what might be considered the golden mean of his ballad approach. The floating phrase Rollins plays at bars 11 and 12 of his solo suggests an elegant dance and provided the inspiration for John Coltrane's composition "Like Sonny."

Working alongside acknowledged ballad masters such as Monk, Dorham, and Davis had helped Rollins elevate his own work at slow tempos. Once he became a full-time leader in the summer of 1957, he was capable of sustaining such performances with the support of only bass and drums. "I Can't Get Started," recorded live at the Village Vanguard, and "Manhattan," from a studio session several months later, are both trio performances where the familiar melodies are refracted in an almost cubist manner, leaving thematic vapor trails among the angular inventions, anguished outbursts, and stream-of-consciousness quotations.

Ballads have remained a central element in Rollins' musical profile, and he has recorded many notable examples in the ensuing decades. While his tone has taken on additional hues, and he has displayed an increased willingness to depart from steady tempos in favor of rubato digressions and more extended cadenzas, the passion and mood shifts of his earlier ballad work have remained admirably consistent. *Old Flames*, an album from 1993 that reunites him with Flanagan and adds a brass choir in spots, is his only collection in which slow tempos predominate, with "I See Your Face Before Me," "Prelude to a Kiss," and a third version of "My Old Flame" among the highlights; but there are many other standout ballads in his discography, including a concise and almost leisurely return to "Blue Room," a quirky duet with guitarist Larry Coryell on "My Ideal," and a pair of more recent performances ("Cabin in the Sky," "A Nightingale Sang in Berkeley Square") that benefit from the sympathetic accompaniment of pianist Stephen Scott.

(PREVIOUS PAGES, LEFT TO RIGHT)
Bob Cranshaw, Kobie Watkins,
Bobby Broom, Clifton
Anderson, Sonny Rollins,
sound check at the Alte Oper,
Frankfurt, November 2008

(FOLLOWING PAGES)
Musikhalle, Hamburg,
November 2008

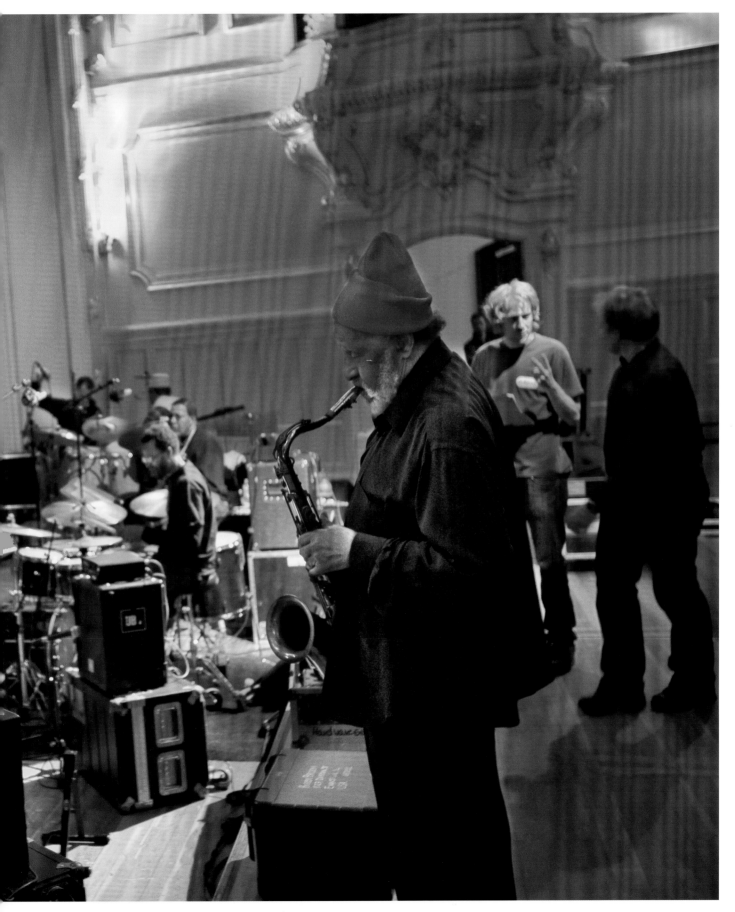

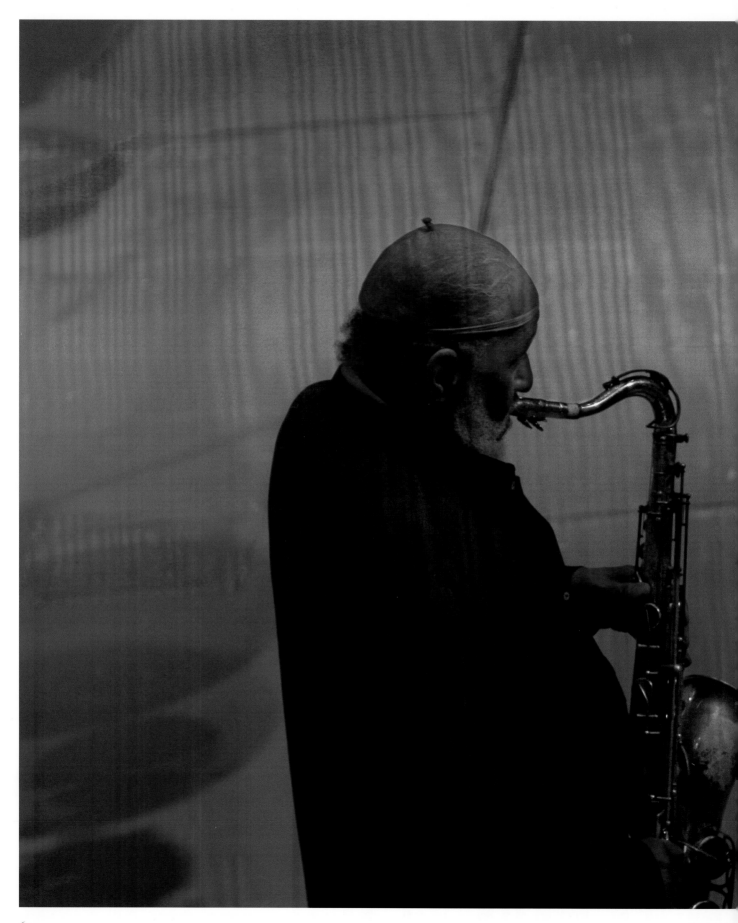

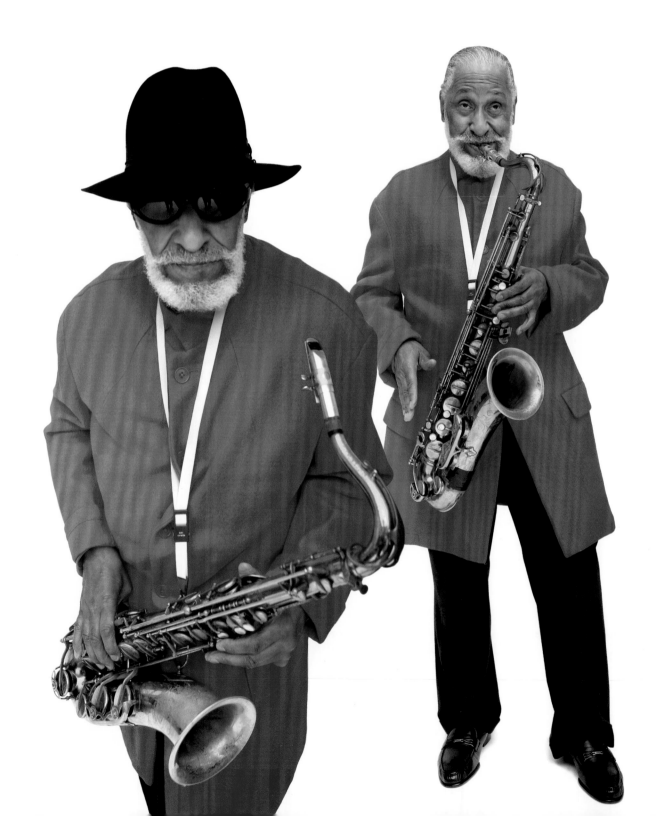

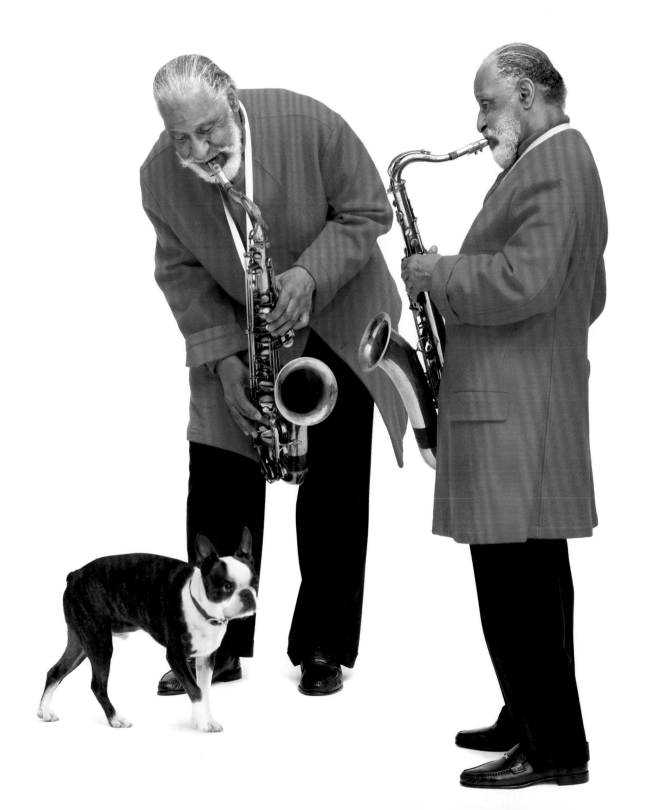

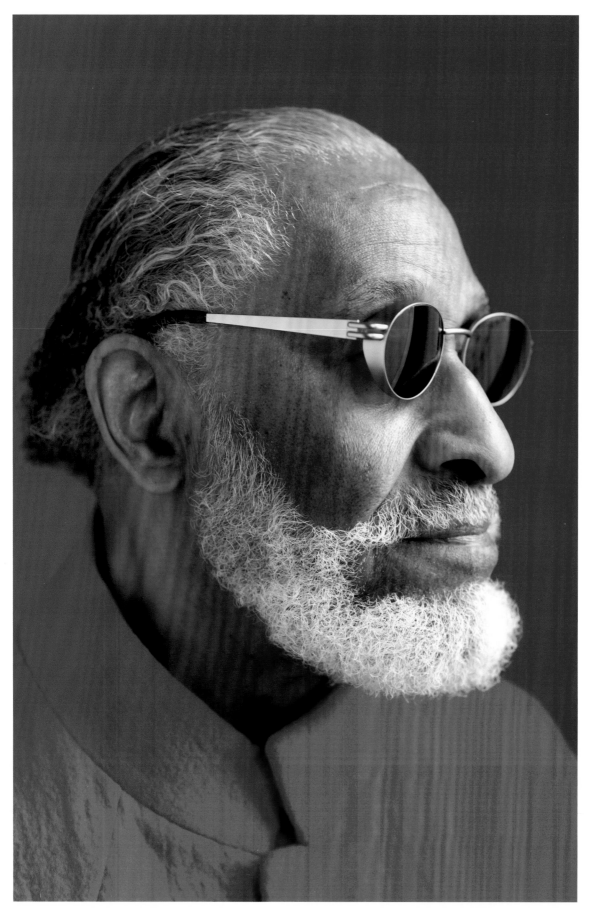

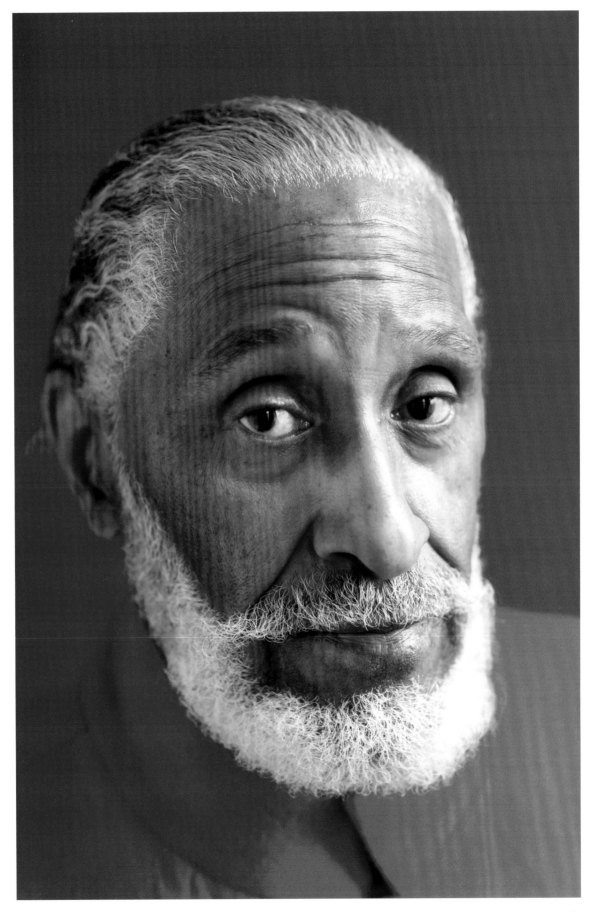

Two of Rollins' most memorable ballads appear on albums that announced his return from the self-imposed exiles that marked the early decades of his career. "God Bless the Child," from 1962, gains a new openness with Jim Hall's guitar in support. By moving in and out of the fixed tempo, Rollins turns his theme chorus into a more heartfelt reading, and he concludes the performance with a swirl of anguished harmonics that suggest a nod of his own to his friend Coltrane.

"Skylark," recorded ten years later, is one of the best examples of the unaccompanied cadenzas that have become as much a part of the Rollins identity as his calypsos. In an introductory chorus and a more abstract and lengthier concluding episode, Rollins stands alone, surrounding bits and pieces of melody with riffs, arpeggios, quotations, and ever-shifting accents. Rollins readily admits that these a cappella forays were directly inspired by "Picasso," Coleman Hawkins' 1948 ballad performance sans accompaniment. "Just the idea of attempting the unaccompanied thing was a breakthrough," Rollins says of the historic Hawkins recording. "It raised the whole level of jazz improvisation on any instrument and elevated the whole profile of jazz."

The only document of Rollins and Hawkins together contains some of the most avant-garde inventions of Rollins' career, especially on two ballads. The Rollins solo on "Yesterdays" begins with a grand fluttering phrase that conjures some prehistoric bird and then becomes the substance of the entire chorus. Both saxophonists are attuned to each other's notions at the start of "Lover Man," handing off ideas as if they were batons in a relay race. Rollins grows more agitated when he gets 32 bars to himself, taking the melody to the sonic edge at several points before dissolving his lines in an altissimo shriek that he sustains even after Hawkins returns with the theme to conclude the performance. To his credit, Hawkins is undeterred by these outbursts, and blows craggy phrases that reflect a similar intensity without loss of decorum. A third ballad from the encounter, "Summertime," sacrifices the extreme effects and gains greater unity, with each tenor ruminating quietly in the background when the other takes the lead.

"He was sort of a father figure," Rollins says of his relationship with Hawkins, "and I always approached him as my superior, not my equal." Yet this did not mean that anything needed to be held back in their musical encounter. Just playing the horn, all out but with dignity, had been Hawkins' overriding lesson, one that Rollins repeats with particular fealty every time he interprets a ballad.

STRODE RODE

ROLLINS THE MODERNIST

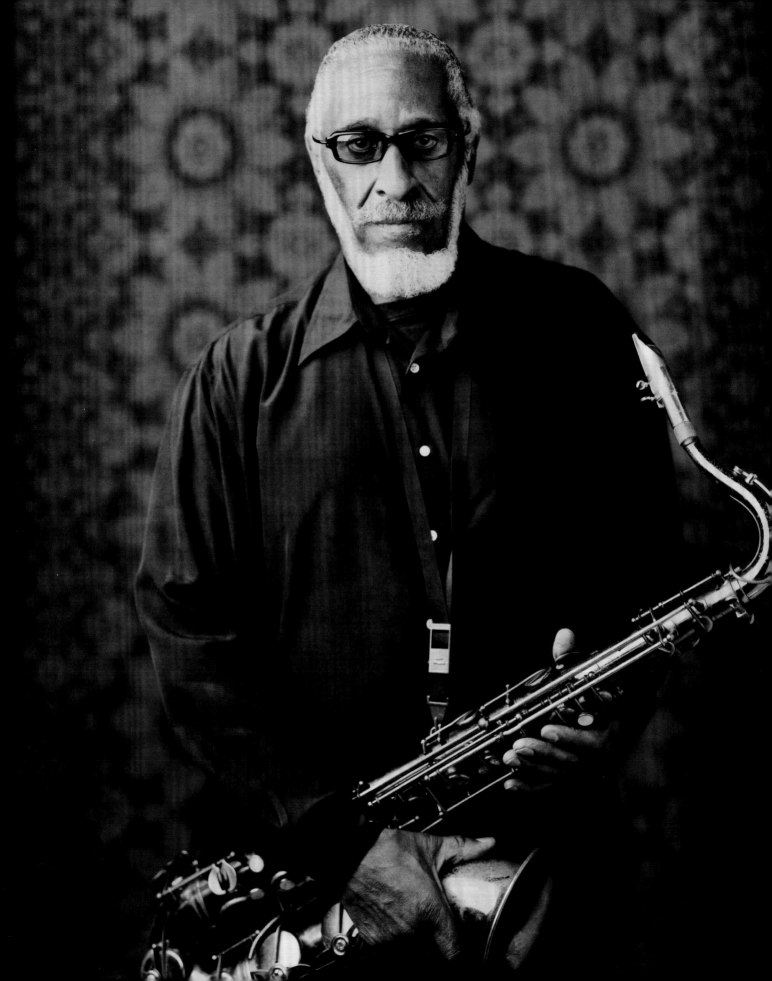

Among its other strengths, *Saxophone Colossus* is an unsurpassed example of the well-made jazz recording in the years when the long-playing album was becoming its own distinctive art form. The new microgroove format, introduced in 1948, did not lead to immediate changes. When Rollins made his first recordings as leader three years later, the emphasis remained on performances brief enough to fit comfortably on one side of a 78 rpm single. At least a few artists, however, took advantage of the expanded possibilities. The Miles Davis date with Rollins that produced the first "My Old Flame" contained

cuts lasting between four and ten minutes, which were released on the short-lived ten-inch "LP," where the playing time averaged twelve minutes per side. By 1955, most jazz musicians were recording more extended track for release on what became the standard twelve-inch album, with twenty minutes of music on each side. Rollins' first collection conceived specifically for the new format, *Work Time*, was recorded that December. In the twenty-nine weeks that separate it and *Colossus,* he would record two more albums, while seeing most of his earlier work repackaged on three others.

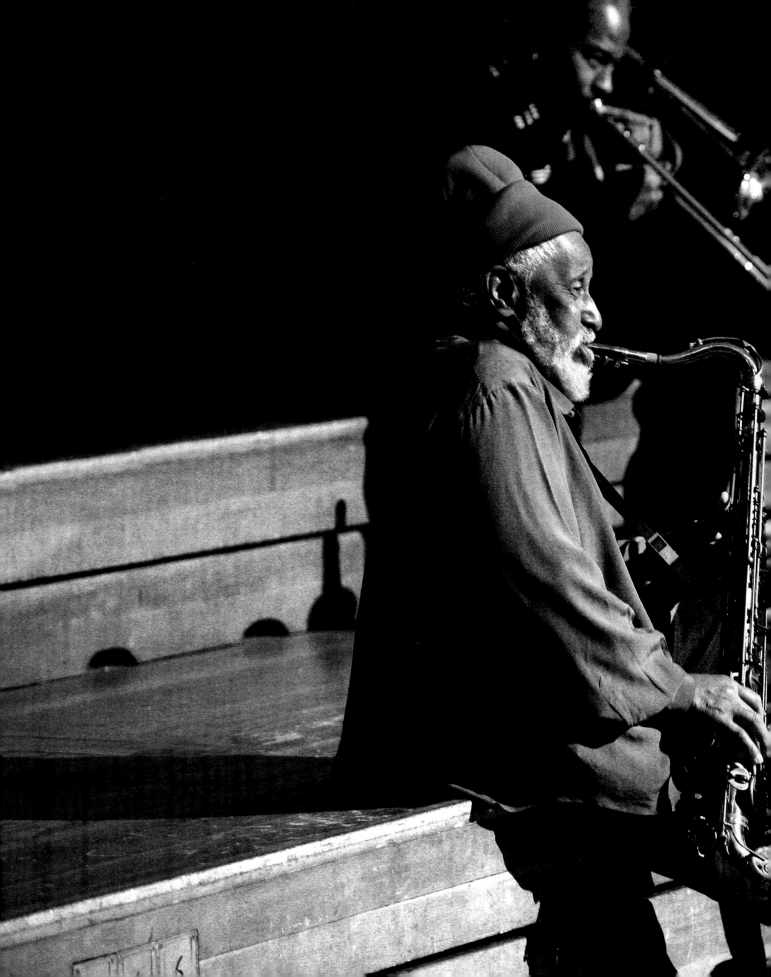

(PREVIOUS PAGES)
*Sonny and Clifton, Hamburg,
November 2008*

(LEFT)
*Miles Davis, Avery Fisher Hall,
New York, June 1991*

(RIGHT)
*Arriving at the Berlin
Philharmonic Hall,
December 2008*

(FOLLOWING PAGES)
*Hamburg,
November 2008*

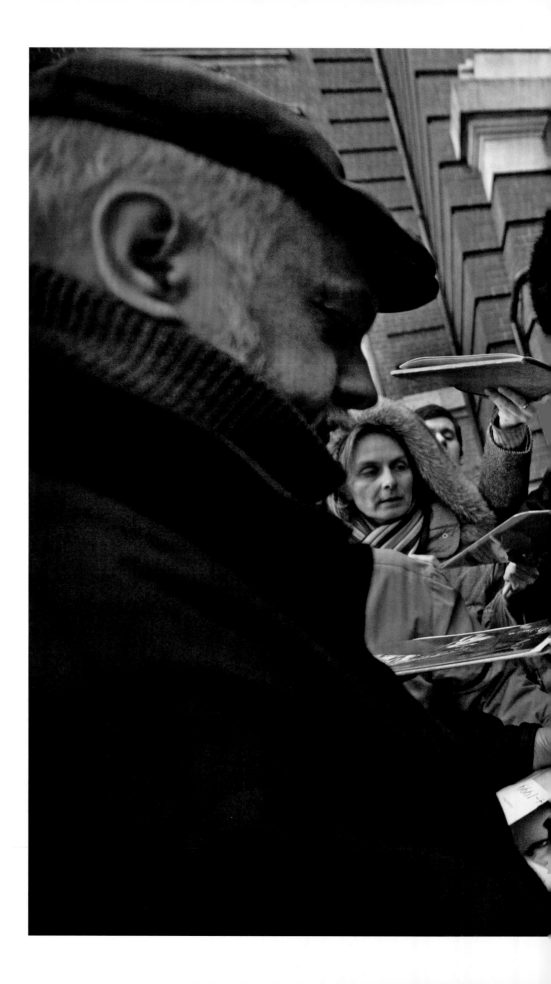

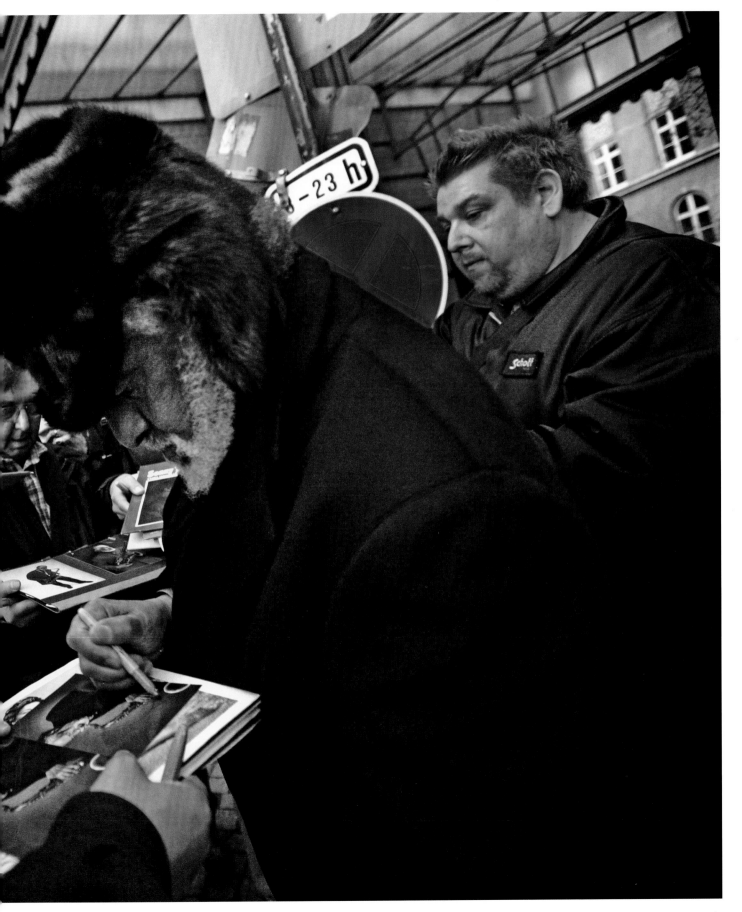

That so much music appeared so quickly suggests the impact of both the new package and Rollins the musician. LPs reshaped listening habits as profoundly as such later innovations as the compact disc and the digital audio file, albeit with less adjustment in the underlying hardware. These well-proportioned containers offered new possibilities in packaging, leading to a host of iconic album covers, as well as for extended programs similarly scaled for enhanced appreciation. One side of a long-playing album still could not contain music of truly epic proportions, but proved lengthy enough to document all but the most lengthy uninterrupted classical music and jazz in a previously unheard facsimile of the live music experience. Frank Sinatra and Miles Davis were among the first to appreciate this potential. They also possessed the conceptual and technical skills to take advantage of the new forty-minute recital, and their careers thrived.

Economics and recording industry conventions made the creation of exceptional jazz albums especially challenging. Artist-owned labels such as the Debut imprint that Max Roach and bassist Charles Mingus created in the early 1950s were decades away from becoming a viable option for most musicians. Rollins, who would not form his own Doxy label until 2006, followed the general example and relied on an established company to document and disseminate his music. Between 1951 and 1956, he was a contract artist and did the bulk of his recording for Prestige, a typical independent jazz label of the period in its production practices. Most Prestige albums featured one-time groupings of players who, thanks to the rigidly enforced three-hour time limit dictated by studio rentals and union contracts, worked under severe time restrictions. For many musicians, especially those like Rollins who labored under its multiyear agreements, the reputation of Prestige was less than stellar. Some of its practices, such as insisting that it publish (and therefore claim a portion of the royalties for) previously unrecorded compositions, were common among its competitors. In other matters, especially its refusal to pay for rehearsals or the additional time required to produce alternate takes, Prestige proved even more restrictive than such competing labels as Blue Note, Contemporary, and Riverside. Rollins had more say in his recordings than most jazz artists, in that he, rather than the label, would select accompanists from the pool of available musicians when a recording session was scheduled. At the same time, he still had the daunting task of creating a balanced repertoire for each album that he and his colleagues could spontaneously interpret in coherent fashion.

Clifton and Sonny, Hamburg,
November 2008

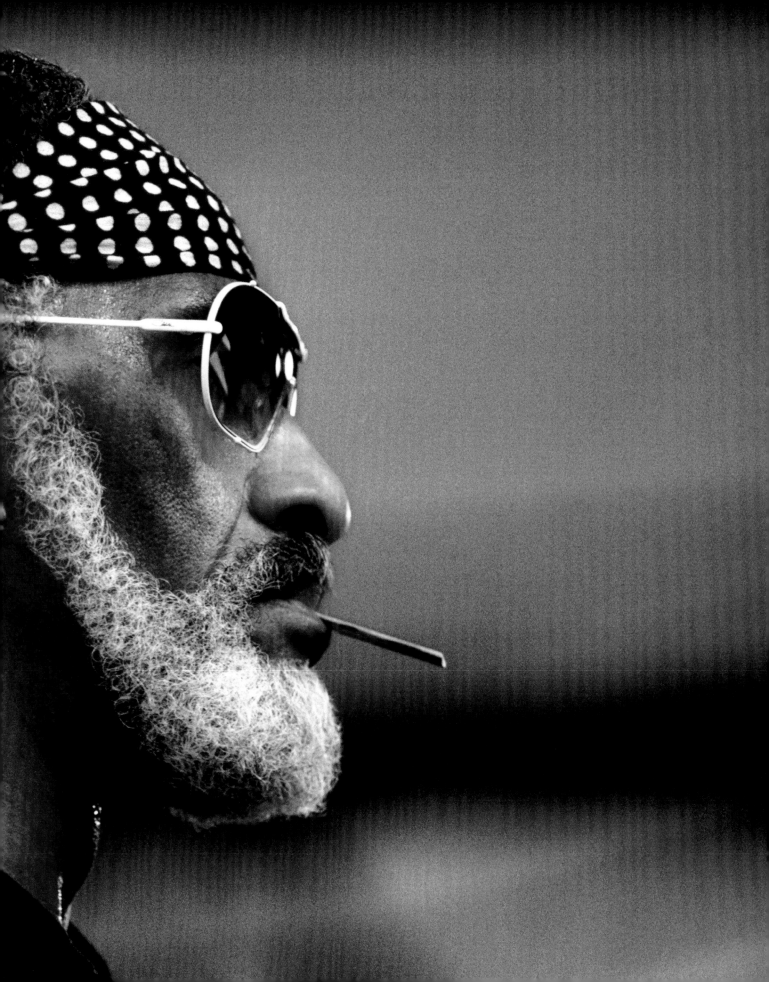

The quartet he assembled for *Saxophone Colossus* is impeccable, blending New York natives Rollins and Roach with two less familiar partners from an emerging generation of Detroit musicians. Pianist Tommy Flanagan, newly arrived in Manhattan, had already recorded with several established leaders, including a March session with Miles Davis in which he first worked with Rollins. The Rollins/Flanagan affinity inspired several recorded reunions before the pianist's death in 2001, as well as the recent Rollins composition "Remembering Tommy." Bassist Doug Watkins had been heard for most of the previous two years in the original Jazz Messengers quintet. This was Watkins' first recording with Rollins, and they would pair up on only one additional occasion, for *Newk's Time* in 1957. (The bassist died in 1962 in a highway accident.) While Watkins and Flanagan were well acquainted from their youth and recorded together on a dozen other occasions, this is the only time that Watkins and Roach worked together. Despite their varying levels of familiarity, Rollins must have felt confident that each member of his quartet was prepared to interpret the standards and original compositions that comprised the *Saxophone Colossus* program.

The notion of "original composition" needs to be qualified in the context of the era's jazz recordings, as some compositions are more original than others. Consider *Saxophone Colossus*, which credits Rollins as composer on three of its five tracks. One of these, "St. Thomas," is a traditional song with no known author and thus in the public domain. Yet the label credited Rollins, no doubt in order to secure the publishing royalties that might follow. At least Prestige had not taken something Rollins actually wrote and assigned authorship to a more famous musician or a producer, another common subterfuge of the period.

Other originals, of which "Blue 7" is a prime example, fell well short of providing unique melodic lines over fresh harmonic sequences. Charlie Parker, like Coleman Hawkins among Rollins' primary inspirations, had created several of his most famous performances over chord sequences borrowed wholesale from earlier popular songs and the blues, with new melodies placed over at least part of the chorus structure. Several early Rollins compositions were styled in this manner, including "Oleo," which follows Parker's example by employing a newly written melody over the chord structure of "I Got Rhythm." "Blue 7," which concludes *Saxophone Colossus*, sounds as if its blues melody had been written, but Rollins has confirmed that only the key, tempo, and solo sequence were set before the tape rolled. Sometimes Parker would omit any statement of melody and just improvise over familiar chord patterns, with only the affixed title suggesting that a compositional process had taken place. Rollins used the chord sequence of "Confirmation," one of Parker's truly original creations, in this manner without supplying any semblance of a predetermined melody on two notable occasions. "I Know," the "audition" track Rollins taped at the end of his initial recording session with Davis, at least makes a titular nod to its source, while the brilliant "Striver's Row" from one of Rollins' classic trio recordings dispenses with all such allusions.

Rollins was also capable of composing in the more traditionally accepted sense. His original pieces, with their vivid melodies and often unique harmonies and forms, allowed him to pose uncommon improvisational challenges to himself and his bands, as well as alternatives to modern jazz conventions that in little more than a decade had become highly predictable. "Strode Rode," one such original, is among the best written and realized in the Rollins canon.

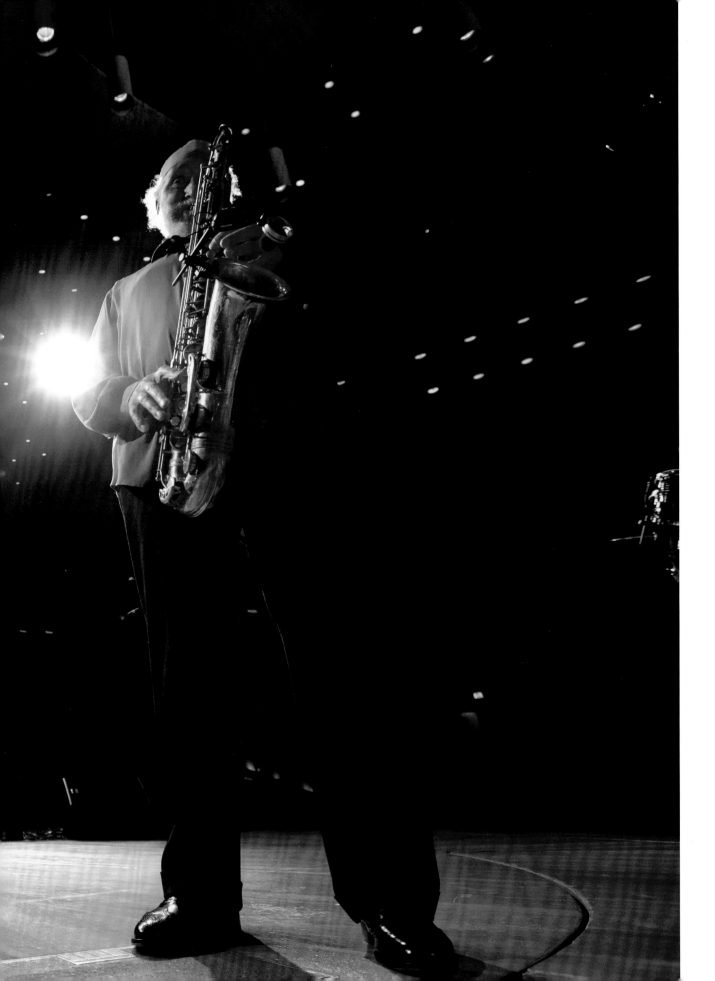

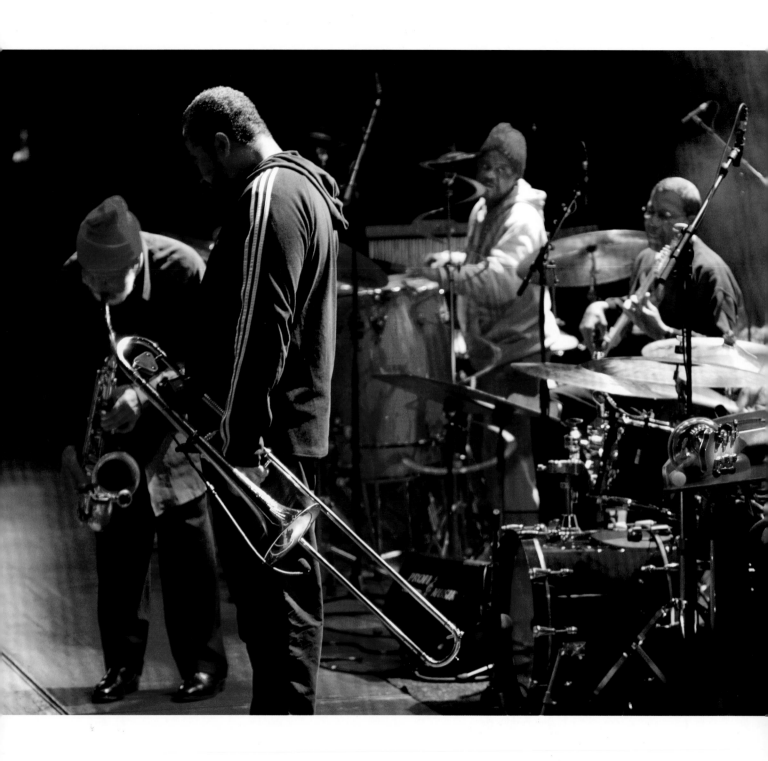

(PREVIOUS PAGES)
*Clifton and Sonny, Berlin
Philharmonic Hall,
December 2008*

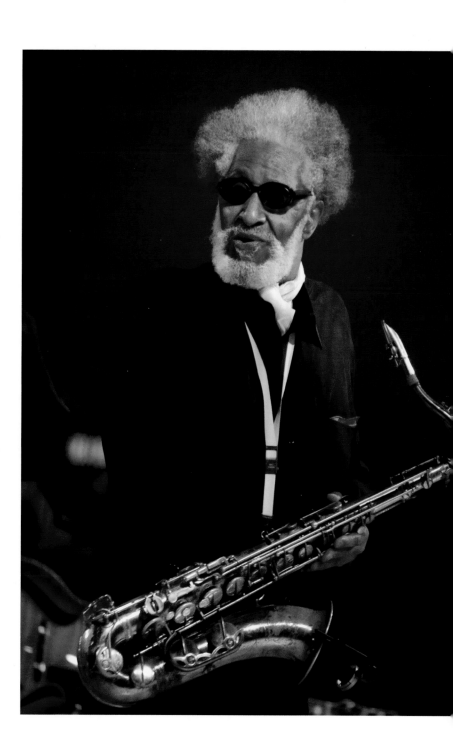

(ABOVE, LEFT TO RIGHT)
Sonny, Clifton Anderson, Kimati Dinizulu,
Bob Cranshaw, Kobie Watkins, Bobby
Broom, Frankfurt, November 2008

(ABOVE)
Berlin,
December 2008

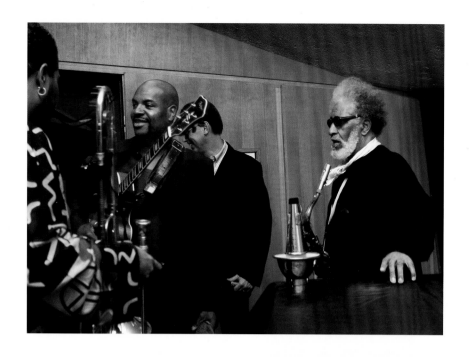

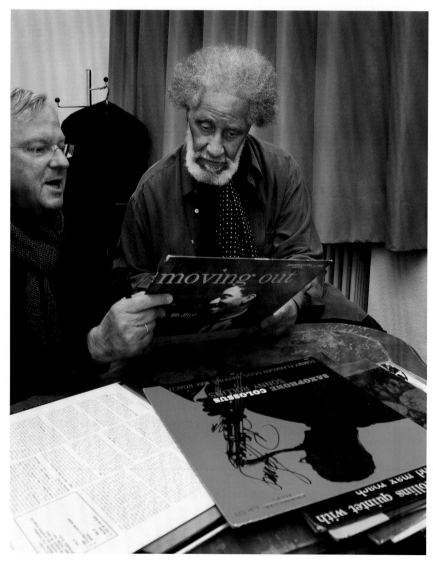

Germany,
November/December 2008

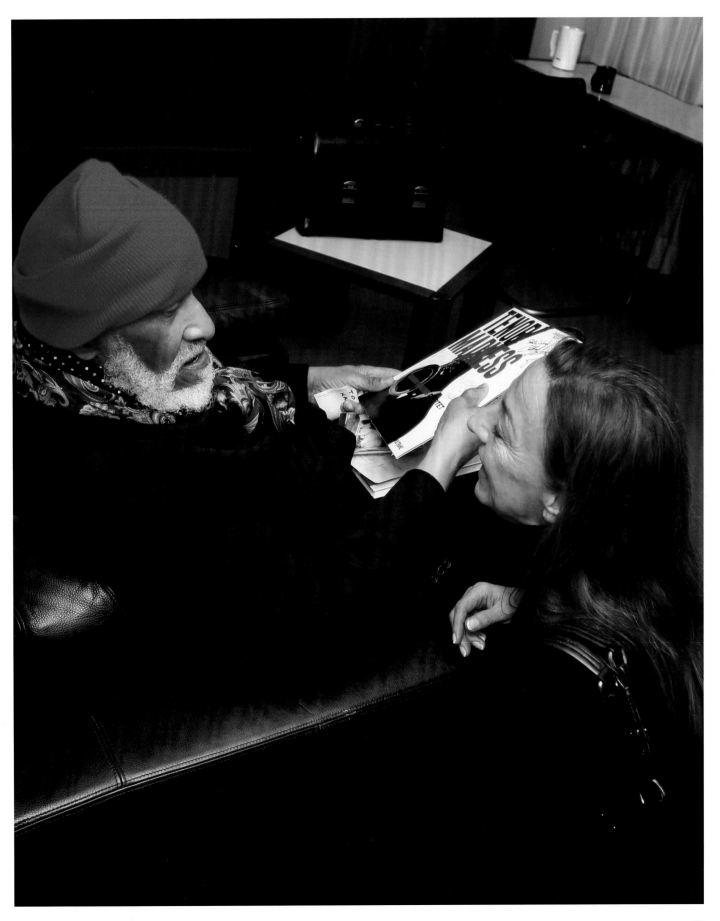

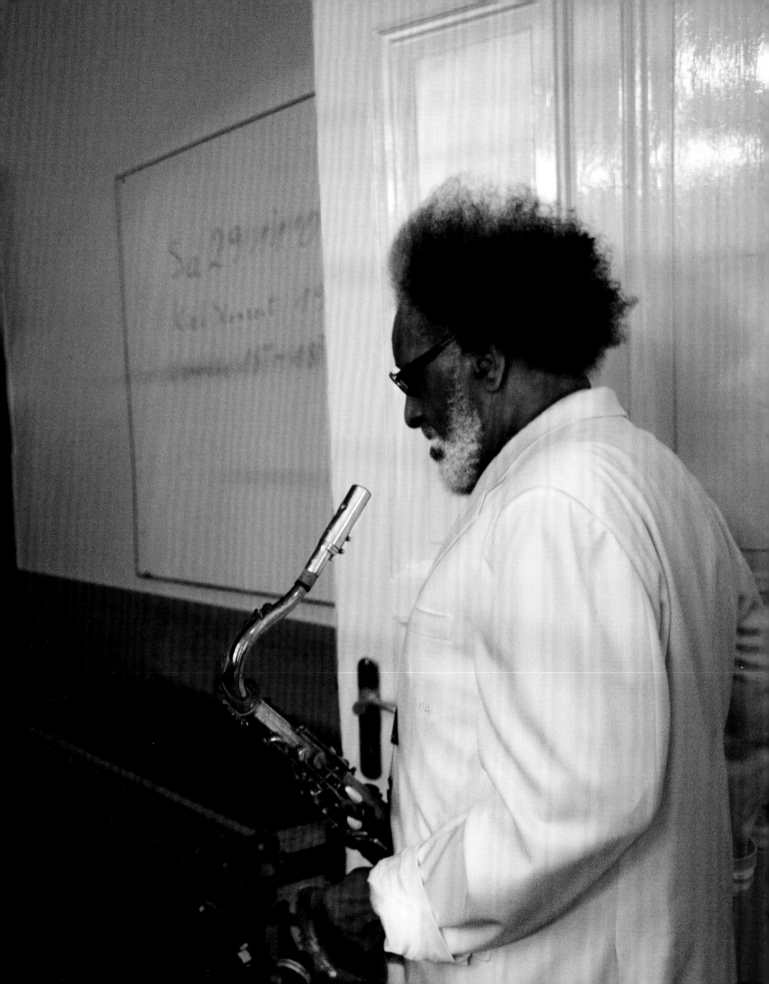

At the structural level, "Strode Rode" diverges from the standard symmetries of 12-bar blues and 32-bar popular songs. Rollins has devised several melodies with unusual shapes over the course of his career, including "Airegin" (with 4 added bars at its center yielding a 36-bar skein), "Way Out West" (five melodic phrases comprising a 20-bar chorus), "Kim" (a song form with the main phrase only 6 rather than 8 bars long), and "Decision" (a 13-bar blues thanks to a mid-chorus interlude). While "Strode" can be said to observe pop-song convention by tracking a familiar AABA pattern, Rollins has revised the standard 8-bar units by extending the primary phrase to 12 bars and cutting the bridge in half, yielding a 40-bar chorus. In addition, and its length notwithstanding, the main phrase is not a blues, but 8 bars of static harmony followed by 4 bars that modulate in a more conventional manner.

On its own, such schematic oddities might offer little more than a challenge (for both performers and listeners) in keeping one's place. "Strode Rode" delivers much more, as Rollins employs three defining elements of his musical persona to make the performance both comprehensible and indelible.

First, he places the rhythm charge that defines his improvising at the center of the written melody. The theme begins with the quartet, in unison, playing a dozen stop-time accents, eight of which are on the same note. Four bars of straight swing sans melody follow, creating a breathing space that reinforces the initial rhythmic phrase, while the succeeding four bars round off the stanza with a more songlike phrase and the first harmonic modulations. An appealing ebb and flow has been created and is reinforced by the more rapid, compacted modulations of the bridge. Through all of this activity, the opening tattoo remains most vivid. When it resurfaces in Flanagan's piano solo and Roach's exchanges with Rollins, it lends further continuity to the performance.

After the theme has been stated, Rollins begins improvising with only Watkins in support for a full chorus. This serves the dual purpose of having the walking bass clearly articulate the harmonic scheme while also building dramatic tension that Flanagan and Roach release upon their emphatic entrance at the start of chorus three. Such textural variation from one chorus to the next had become identified with Rollins and Davis after the pair employed the strategy on their 1954 recordings of the Rollins compositions "Airegin" and "Oleo." Rollins is unsure who originally came up with the idea that the pianist and/or drummer lay out ("I'll give Miles the benefit of the doubt, since it was his date," he has offered), but the notion sprang from a shared desire to escape harmonic constraints imposed by a pianist's choice of supporting chords. In the two years after *Saxophone Colossus* was recorded, Rollins

extended the idea further on his classic recordings *Way Out West, A Night at the Village Vanguard*, and *Freedom Suite*, omitting piano and establishing what would become a classic tenor sax/bass/drum trio format.

After Flanagan has soloed on "Strode Rode," Rollins and Roach engage in four-bar exchanges, a practice known in the vernacular as trading fours. Such back-and-forth interludes were common enough among musicians in general, and saxophonists and drummers in particular. Few, however, were prepared to converse with the spontaneous cogency of this pair, as Rollins' rhythmcentric melodies are perfect complements to Roach's melodic rhythms. Their "Strode Rode" dialogue is inspired, yet contains eight extra bars in each chorus, indicating that one or both players may have lost track of the form. This is hardly noticeable, and suggests how even the greatest jazz performances may transcend what some might consider imperfections.

In tempo, energy, and mood, "Strode Rode" is the most boppish track on *Saxophone Colossus*. It is therefore fitting that its initially confounding title contains what Rollins explains as a reference to a little-known bebop pioneer. "'Strode Rode' is named for the Strode Hotel in Chicago," Rollins has said. "That's where Freddie Webster died, I believe of an overdose." Webster, one of the first trumpeters to play in the modern jazz idiom, was known for possessing a sound of uncommon beauty and has been credited as an influence on both Miles Davis and Fats Navarro. He made few recordings before succumbing to his drug habit in 1947. By acknowledging, however obliquely, both Webster and the Chicago site of his demise, Rollins was also making reference to his own, similar struggles.

Heroin was a stumbling block that tripped up an entire generation of musicians, and Rollins has never been less than frank in describing his personal involvement. "Drugs passed through like a tornado in the early fifties," he has noted. "Guys came back from Korea smoking heroin. It was plentiful, and I was hooked pretty bad. It was a thing we all went through. Some of us came out of it, and some didn't. I did."

For Rollins, the battle, while ultimately successful, was protracted. At his first quartet session in 1951, his situation was such that he reportedly employed a coat hanger held around his neck by a length of rope in place of a saxophone strap. He spent much of the following year "carving the rock" (a hip way to say doing time at New York's Riker's Island facility) and went right back to using heroin upon his release. This led to a memorable conversation with the jazz world's most notorious junkie, Charlie Parker, at a Miles Davis recording session at which both Parker and Rollins were heard on tenor sax.

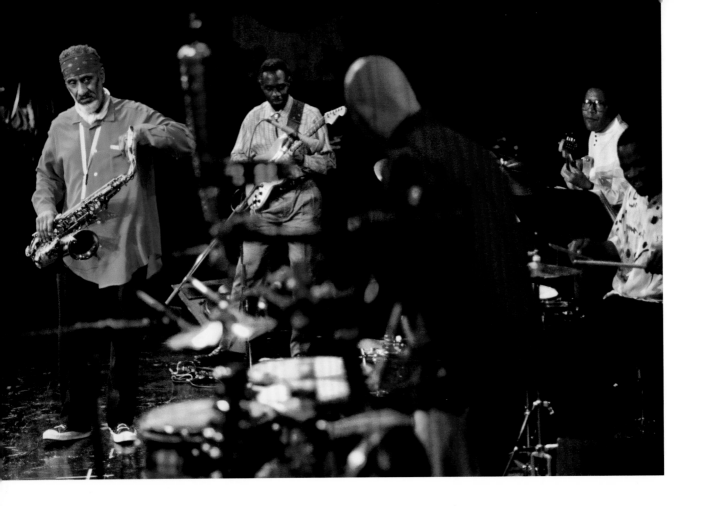

(LEFT TO RIGHT)
*Sonny, Jerome Harris, Victor Y. See Yuen,
Bob Cranshaw, Bruce Cox, Tarrytown
Music Hall, Tarrytown, NY, April 1994*

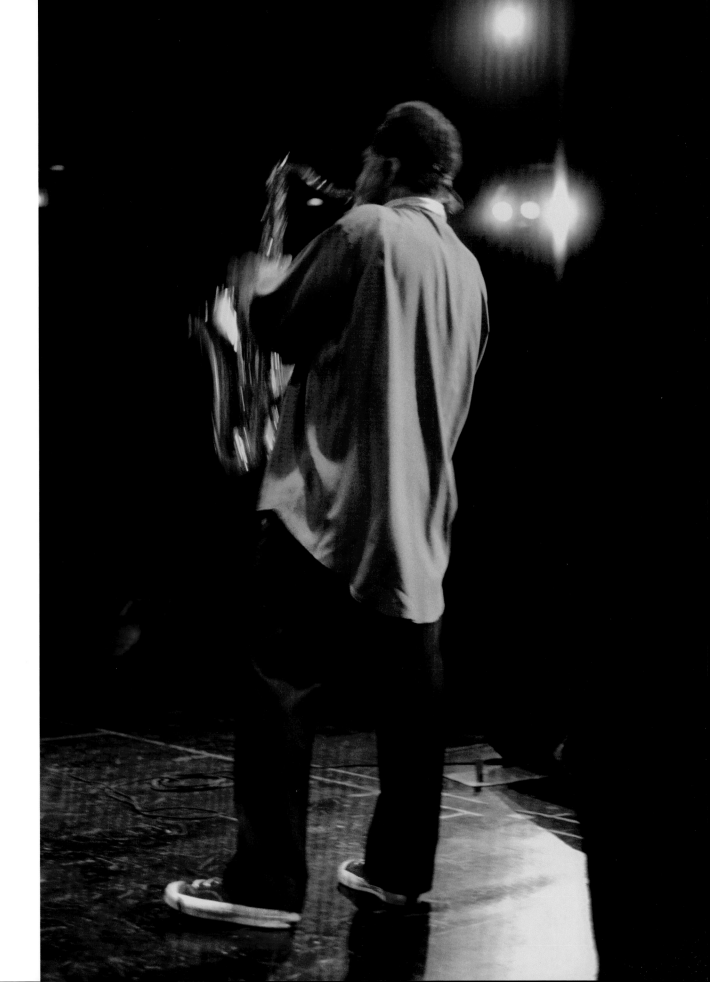

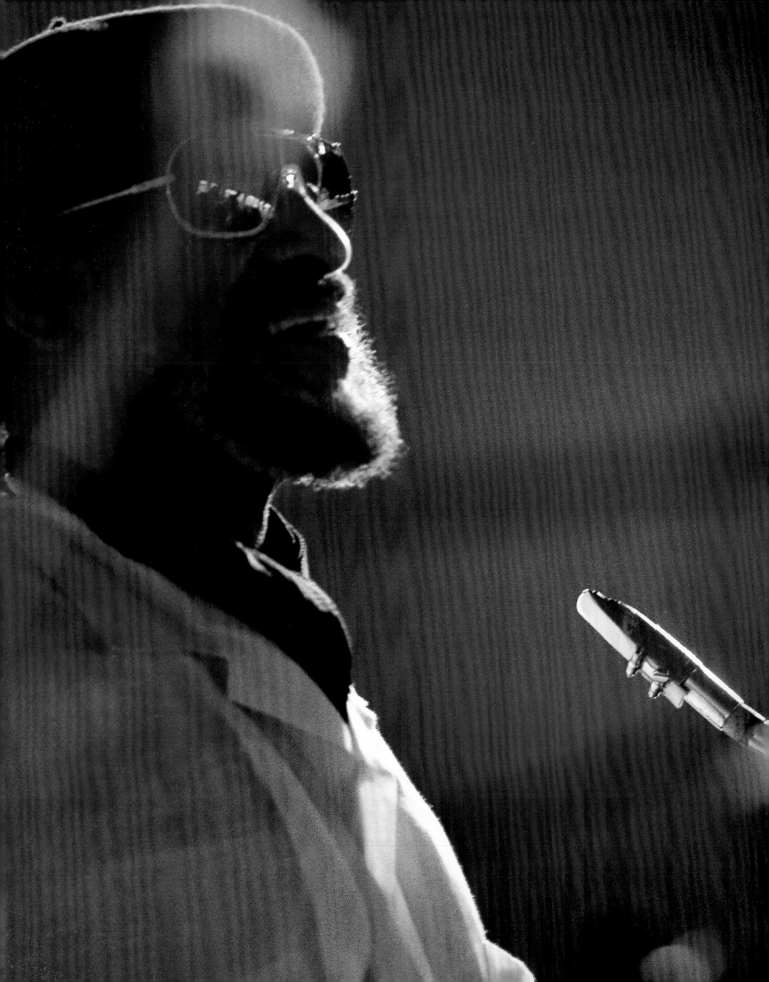

New Orleans,
April 1993

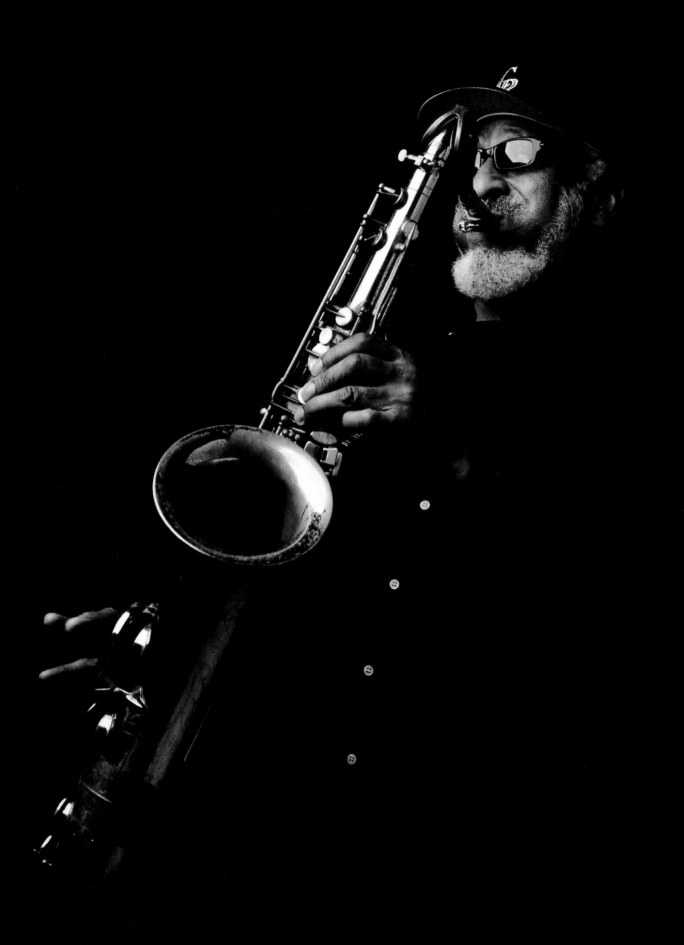

"I'm sure that Bird thought it was because of him that I was using heroin," Rollins has recalled, "and he asked me at the session if I was straight, because he knew I was on parole at the time. I lied and told him that I was, but at a break somebody else mentioned that I had gotten high before the session. That's when Bird told me that I could be a great musician if I didn't mess around, and this motivated me. I wanted to show him that one of his followers got the message."

Three more years would pass, and Parker would die of drug-related causes, before Rollins could claim victory over his drug habit. Despite continued growth as a musical force, his physical condition was deteriorating, and this together with Parker's remembered admonishment led Rollins to voluntarily enter the federal drug facility in Lexington, Kentucky, at the end of 1954. After four and a half months in Lexington, Rollins chose to continue his recovery in Chicago. He took a room at the YMCA, found work as a janitor and a laborer loading trucks, and practiced music in his spare time. "*Then* it started," he once explained, "the real test. Guys coming up to you at sessions and offering you stuff, and your palms sweating; you've seen it in the movies. There I was struggling, working my little day job, and right around the corner from the YMCA where I was living was a record store with my latest album in the window. It was tough; but I had my loose-leaf notebook with various things I wanted to work on. I was always working on something and learning new songs."

Rollins took the majority of 1955 to pull himself together. Miles Davis called in the summer with an offer for Rollins to join the trumpeter's new quintet, but he turned down the opportunity, and the job ultimately went to the then-unknown John Coltrane. In November, Rollins subbed for Harold Land in the Clifford Brown/Max Roach Quintet when the band visited Chicago, and felt confident enough to join the group and return to the road at month's end. The inspired composition he recorded six months later is therefore a dual celebration, of both Freddie Webster's memory and Rollins' own ability to reject the forces leading him down the same tragic road.

MORITAT

SONNY & SONGS

Jazz musicians have played a key role in establishing the popular song canon from the moment Louis Armstrong recorded "I Can't Give You Anything but Love" in 1929, and it was Armstrong who had first turned the Kurt Weill melody that we now know as "Mack the Knife" into an English-language hit with his 1955 recording. Sonny Rollins employs the German title "Moritat" (which translates as "deadly deed," the German phrase used to describe the medieval murder ballad), indicating familiarity with Lotte Lenya's interpretation on a recent album of the period; but the song's presence on *Saxophone Colossus*, like Rollins' recording of "Count Your Blessings" three months earlier, is also indicative of an ear attuned to the hit parade.

This was a matter of personal preference rather than commercial strategy. "It's mysterious why you like certain songs," Rollins offers. "It might be the harmonic structure as much as anything else. That's something I had in common with Miles Davis; we both liked obscure songs. I went to the movies every week when I was a kid, and heard a lot of songs in movies that struck me in a funny way." When recalling his early encounter with idol Coleman Hawkins in a theater, Rollins was quick to point out that the movie he had come to see was *The Shocking Miss Pilgrim.* "I remember," he noted, "because a song by one of my favorite composers was in that picture, Friedrich Hollander's 'This Is the Moment.'"

What sets Rollins apart from most jazz musicians is a taste for material that others consider trivial. "Shadrack" and "There's No Business Like Show Business" had each been around for a decade or more before he provided the first instrumental jazz versions of the songs, and if "Moritat" was not as unprecedented in a jazz context, it was hardly an obvious choice for inclusion in the program of a cutting-edge modernist. The piece, like so many others, proved ideal for a player of Rollins' talents. The pithy singsong tune lends itself to a swing beat and leaves well-placed space for variation, while the harmony is similarly direct, with a striking modulation marking the halfway point in the chorus. "Moritat" is a simple song with substance, one that even a jazz novice could follow during the course of complex improvisation.

Rollins and his rhythm section reveal the cornucopian potential of Weill's theme, with the firm insistence of Roach's beat and Flanagan's wistful commentary introducing contrasting attitudes in the opening chorus that Rollins expands upon in his tenor solo. To paraphrase Marc Blitzstein's English lyrics, Rollins blows "like a sailor," tacking on and off the melody with shifts in direction, arpeggiated tempests, deep soundings from the bottom of his tenor, and an unlikely recollection of his earliest years, "Bouncing with Bud." Flanagan glides through his choruses, providing an elegant contrast to the more rambunctious tenor; Roach shows elevated sensitivity to his kit's sound, especially at the point where his exchanges with Rollins become a drum solo proper; Watkins abandons walking bass lines for the only time on the album while still making the beat visceral; and the Rollins/Roach fours introduce an attitude of raucous wit.

Exaggerated phrasing, abrupt exclamations, and other forms of humor have always played a large role in Rollins' music, and he has been particularly adept at salting his improvisations with numerous snippets of other songs. Sometimes the quotations appear to carry specific meaning, although Rollins insists that no boast was intended when he cited "Anything You Can Do I Can Do Better" while blowing alongside Miles Davis and Charlie Parker on "The Serpent's Tooth." More often, the link can be traced to suggestive melodic and harmonic shapes, as is the case when "Bouncing with Bud" finds "Moritat." (If a more literal commentary were intended, Rollins might have referenced another of his efforts with Bud Powell, "Dance of the Infidels.") For Rollins, humor is often more a matter of phrasing and inflection. In any form, it has been so omnipresent as to become a defining strategy, one often misunderstood by even his closest colleagues. "Humor in music is a very subjective thing and should be a natural thing," he has insisted. "It's difficult for me to talk about the lack of it in others' music, because I admire guys who are very serious and play seriously. Because of the humor in my music, people have accused me of not really playing, of just playing around. John [Coltrane] told me that about 'Tenor Madness'; he said, 'Aw man, you were just playing with me.'"

"Tenor Madness," the blues that serves as title track to the album Rollins recorded a month before *Colossus*, is the only recorded example of Rollins and his good friend Coltrane playing together, and it underscores a significant difference in their respective approaches. If not humorless, Coltrane was relentlessly serious, while Rollins might leaven solos with notions ranging from whimsical innuendo to slapstick pratfall. This distinction becomes clearer as "Tenor Madness" proceeds from individual solos to fours between the saxophonists and drummer Philly Joe Jones, and ultimately to direct two-tenor exchanges. At one point, after Coltrane has labored heatedly over a pet ascending figure, Rollins responds by juggling the same lick, and then playing it backwards.

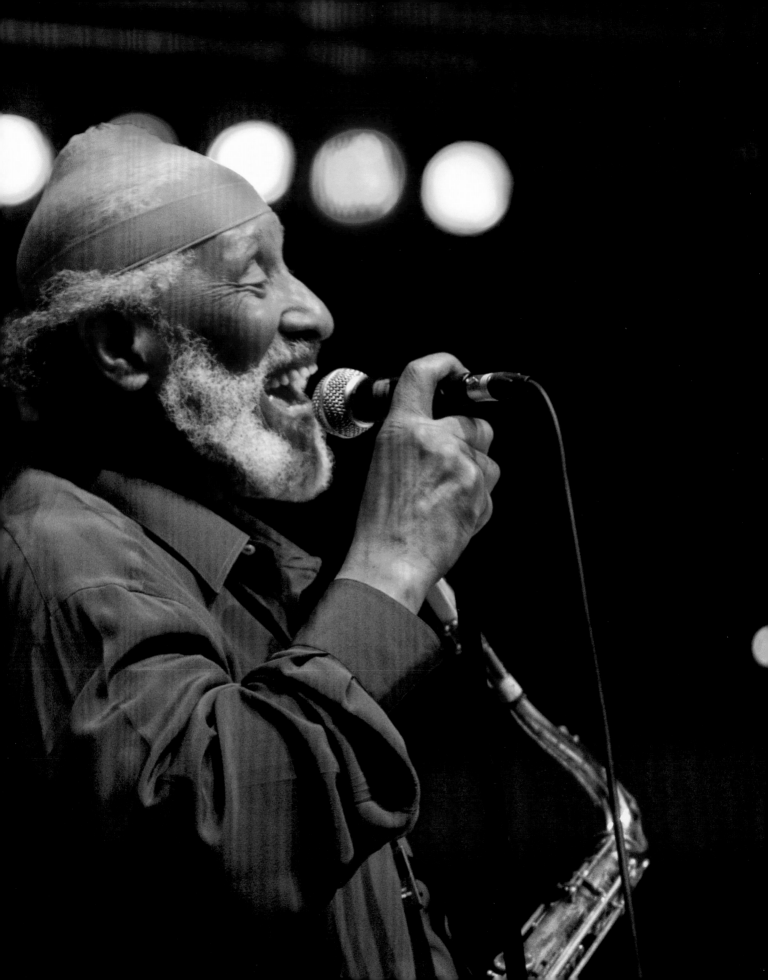

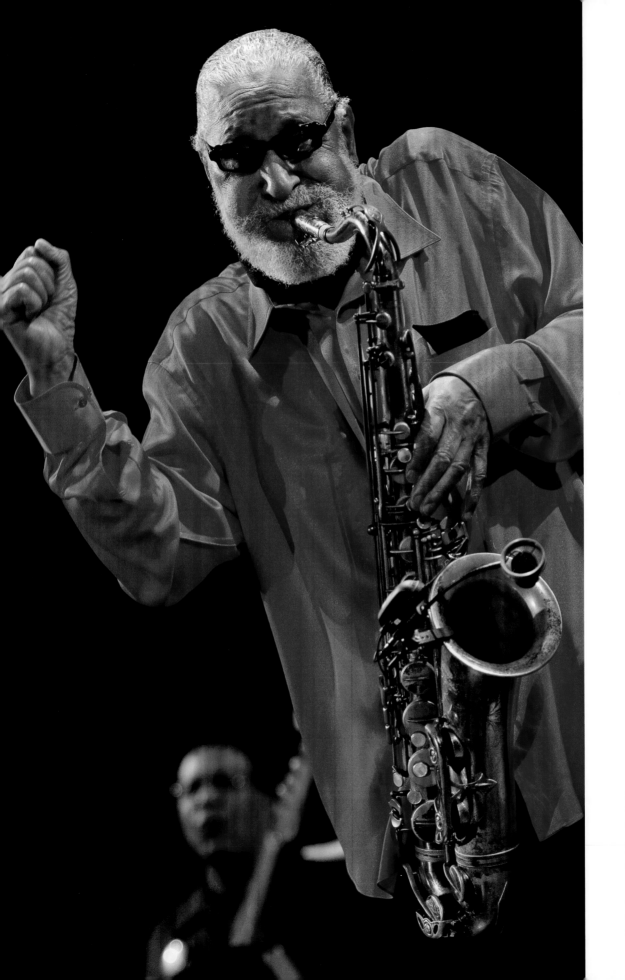

(PREVIOUS PAGES)
Sonny sings, Berlin,
December 2008

(LEFT)
Sonny and Bob Cranshaw,
Tarrytown, NY, December 2009

(FOLLOWING PAGES)
Sonny's music stand,
Frankfurt, November 2008

Another Rollins trademark, which is otherwise absent from *Saxophone Colossus*, is hinted at in the final four bars of "Moritat." As the recapitulation concludes, the band drops out and Rollins breaks into an out-of-tempo cadenza. The unaccompanied foray here is only a seed, with the first full-blown example on record of Rollins' unaccompanied playing, "It Could Happen to You," appearing a year later. The primary inspiration once again was Coleman Hawkins, who had recorded a historic solo exploration of the "Body and Soul" chord sequence under the name "Picasso" in 1948. Rollins would soon take his own a cappella pass at "Body and Soul" and introduce even lengthier cadenzas in later live performances. There is no better example than his introduction to "Autumn Nocturne," from a 1978 concert at San Francisco's Great American Music Hall. For over four minutes, ideas pour one after another from his horn in whiplash motion, with the process of free association yielding themes from all corners of the Rollins memory bank: "I'll Close My Eyes," "Falling in Love Again," the paraphrase employed on Rollins' recording of "The Way You Look Tonight," the "Going Home" theme from Dvorak's *New World Symphony*, "No Place Like Home."

The 56-minute "Soloscope," created in the Museum of Modern Art's Sculpture Garden in 1985, remains Rollins' only all-solo effort. While a testament to both his physical and imaginative resources as well as a test of any listener's knowledge of pop, jazz, and classical themes, the recital lacks the thematic markers that shape and sustain Rollins' best improvisations. Still, the event conjured an image of Rollins the lone improviser that has become part of his legend and that he embraces as the core of his persona. "When I got my first saxophone, I would practice for hours and hours and be in a completely happy place," he recalls. "I still like to practice in isolated places where it's just me, nature, and my horn."

These reveries are likely to call up some of the oddities that dot his discography. They include such unlikely titles as the Al Jolson signatures "Toot, Toot, Tootsie" and "Rock-a-Bye Your Baby with a Dixie Melody," the cowboy anthems "I'm an Old Cowhand" and "Wagon Wheels," and a pair of titles with South Seas implications, "Sweet Leilani" and "The Moon of Manakoora." This is not to mention the more familiar warhorses that form a reliable part of every Rollins performance. Even during the early 1960s, when Rollins hired half of Ornette Coleman's first quartet and introduced a greater degree of collective improvisation than his music has featured before or since, he continued to build performances around "Dearly Beloved" and other standards.

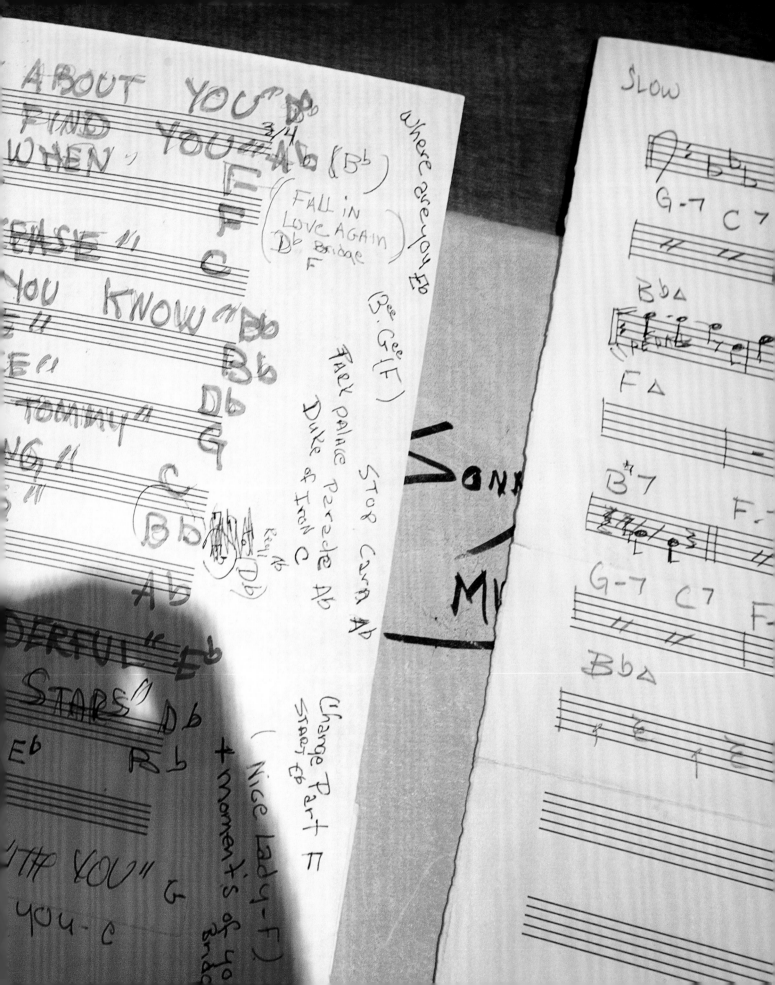

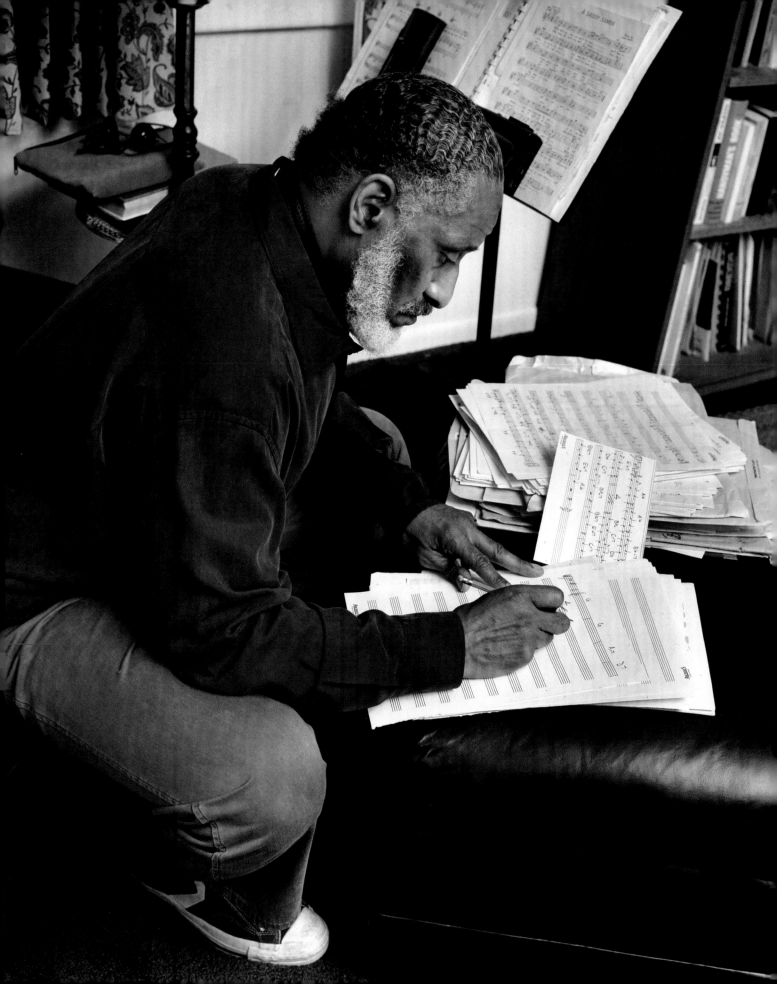

Germantown, NY,
August 1995

Germantown, NY,
August 1995

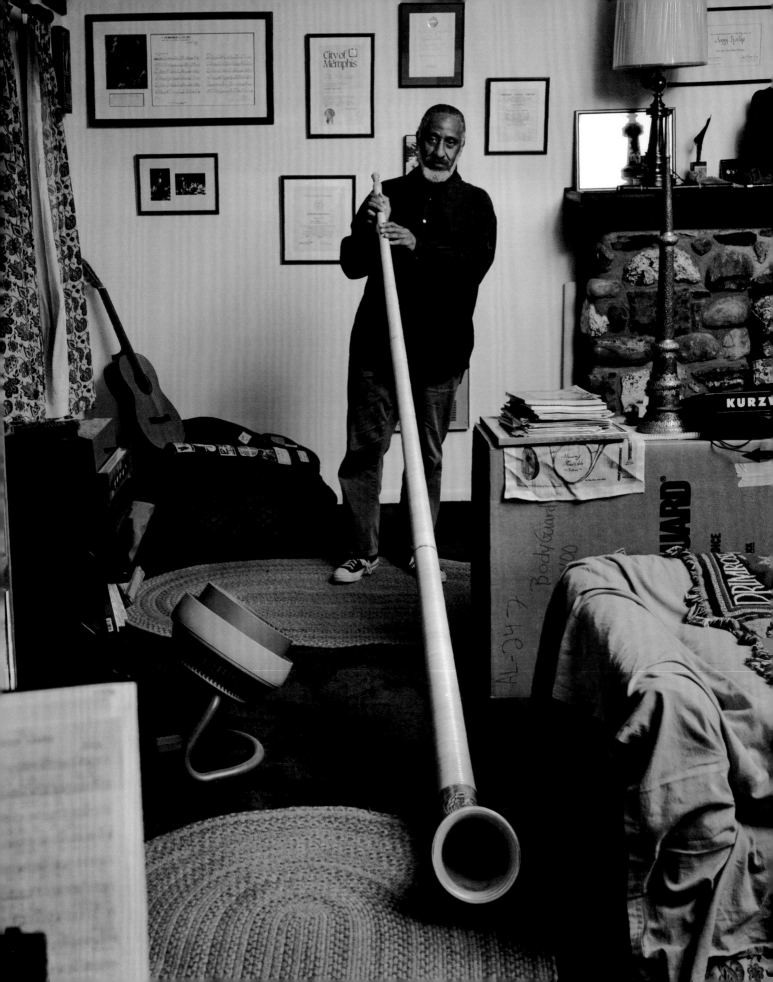

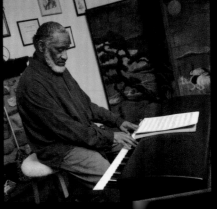

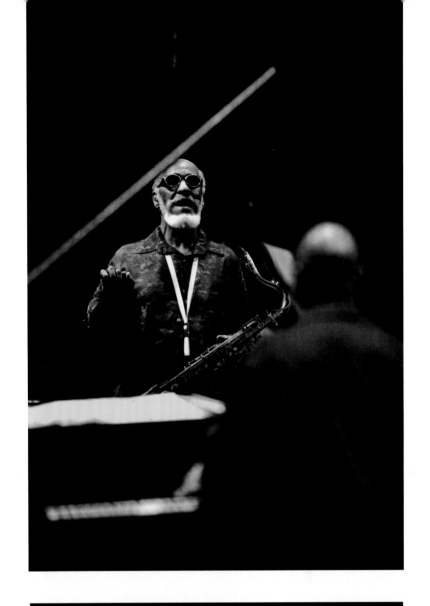

Sonny in his Germantown, NY
studio, August 1995

Sonny and Stephen Scott,
Newark, NJ, November 1999

Tommy Flanagan,
March 1996

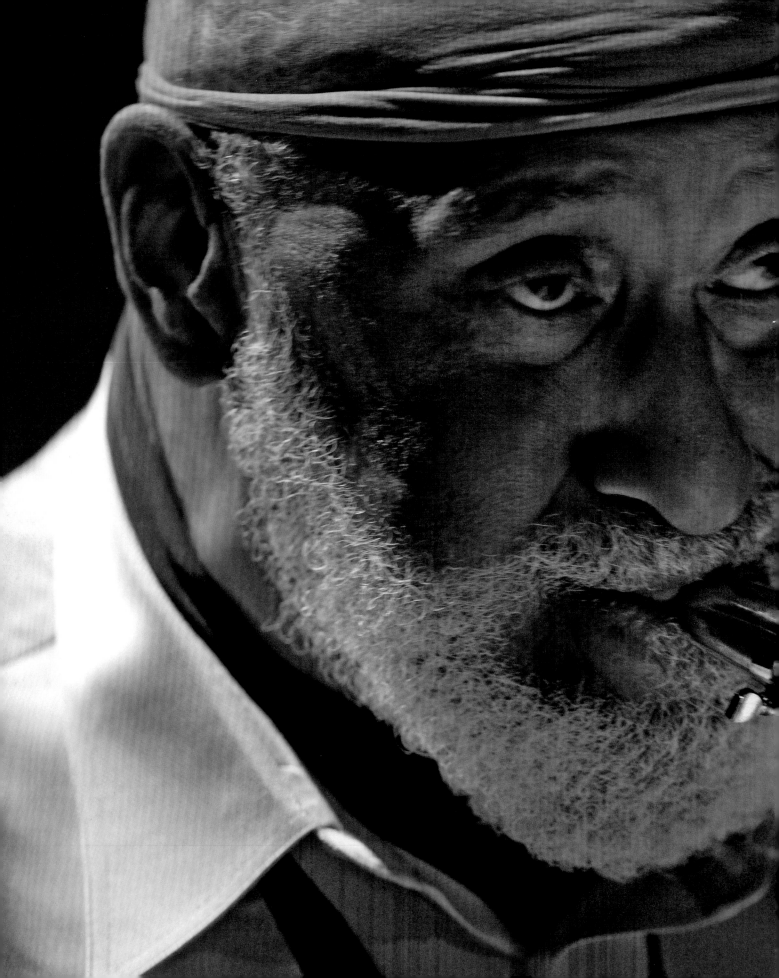

In the early phase of Rollins' career, these nostalgic mementos were balanced with new popular material, with the Broadway stage serving as a primary source. His recordings of "I've Grown Accustomed to Her Face," "Namely You," "Till There Was You," and "If Ever I Would Leave You" were all made while the songs' respective musicals were still in their first runs. By the mid-1960s, most popular songs held less allure for the jazz improviser, and while Rollins has embraced Burt Bacharach's "A House Is Not a Home" and Stevie Wonder's "Isn't She Lovely?" he is far more likely to gravitate toward the likes of "I'm Old Fashioned" or "Tennessee Waltz." Rollins may indeed be old-fashioned at this point in popular culture, when the 1947 hit "Tennessee Waltz" seems hoary enough to have originated a century earlier; yet through greater and lesser modifications in his approach, the echoes of the greater and lesser melodies from his youth have kept him grounded in his own and jazz's foundations, and have instilled a common touch in his music that continues to make a world of fans comfortable with his more abstruse creations. Rollins had what can serve as both the last word on the subject and a summary of his philosophy of art and life when, in a Boston concert four days after the destruction of the World Trade Center, he began the evening by playing "Without a Song."

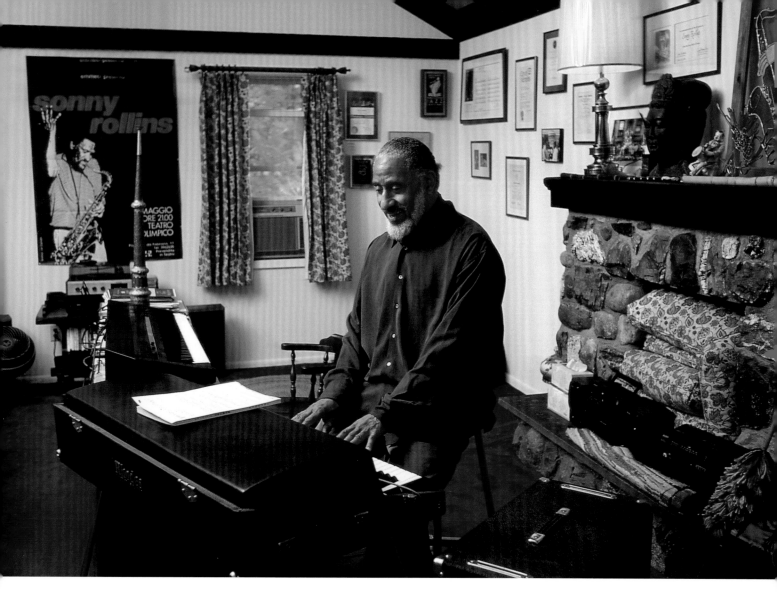

Germantown, NY,
August 1995

BLUE
7

SONNY'S THEME

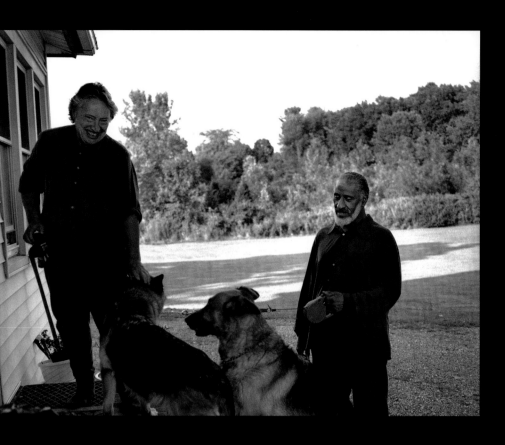

POST CARD

文楽　江戸時代に現われた日本人形劇の代表的なもの。三
人で一つの人形を操る。浄瑠璃の切々たる語りに合わせて、
喜び、怒り、悲しみを、きめこまやかに表現する文楽人形の
所作は、人間以上に人間を感じさせる。

Bunraku: The Japanese puppet theater which was popular
during the Edo Period (about 300 years ago).

photo : Takeji Iwamiya Printed in Japan

10/18
Tokyo
Dear John — Just
to let you know
we had our first
(of 10) concert in
Yokohama. last nt.
& saw the program,
your photo (& words) Beautiful!
Best
Sonny & Lucille

Air Mail
Par Avion

John Abbott
300 W. 55th St.
New York, N.Y.
10019
USA

Lucille and Sonny Rollins
with their dogs Brigadier
and Carrie, Germantown, NY,
August 1995

Saxophone Colossus is different from other classic jazz recordings by the very nature of its creation. Working bands with a substantial performance history recorded Miles Davis' *Kind of Blue*, Dave Brubeck's *Time Out*, and John Coltrane's *A Love Supreme*, albums with a similar iconic status. Each of these discs is also built around an overriding theme that imposes unity on their respective programs. In contrast, Rollins, Flanagan, Watkins, and Roach formed an impromptu ensemble, one with a life no longer than the three hours it spent in Rudy Van Gelder's recording studio, and the material Rollins selected lacked any preordained connections. Yet collectively, the individual performances create a greater entity and a spontaneous cohesion. No single performance, here or elsewhere in the Rollins canon, distills this alchemy as effectively as the final track on *Colossus*, "Blue 7."

Rollins has confirmed that the piece was created spontaneously at the recording session. It is a minor blues, a structure with which each of the musicians was extremely familiar, and its realization required little more than choosing a key, determining the order of solos, and counting off the tempo. When Doug Watkins began his introductory chorus of walking bass, none of the players knew much more than when they would enter and at what point their opportunity to solo would occur. Yet Rollins, with the others responding in kind, generated more than eleven minutes of music with the developmental and emotional coherence of a well-wrought sonata. The first idea Rollins plays, a four-bar phrase with A-flat as its arresting second note (A-flat being the "blue 7" in the home key of B-flat), becomes the linchpin in all that follows in three discrete saxophone solos of six, five, and three choruses each, plus two further choruses of exchanges with Roach. The phrase is directly reiterated at some point in each of the solos, but more commonly modified in ways that surprise and delight while maintaining at least a shadow of the original. Roach, with his own penchant for melodically sculpted drumming, reinforces the motto in a solo of nearly seven choruses, as does Flanagan both during his own solo and in the support he provides to Rollins, while Watkins carries the beat implacably forward. What results is an improvisational masterpiece that invited the most detailed analysis, yet conveyed a clarity that even a jazz novice could appreciate.

A mastery of the blues form had been evident in Rollins' playing since his 1949 "Dance of the Infidels" with Bud Powell, and he had previewed this motif-driven approach three months earlier when he and Flanagan recorded "Vierd Blues" with Miles Davis. After "Blue 7," however, Rollins was celebrated as a master of not just blues playing but a particular kind of blues playing, one that married logic to lack of inhibition. This mastery was reinforced over the succeeding two years in a passel of additional blues masterpieces, including the furious "Ee-Ah" and caustic "Ba-Lue Bolivar Ba-Lues-Are" from later in 1956; "Blues for Philly Joe," "Sonnymoon for Two," and "Sumphin'" in 1957; and "Bags' Groove" in concert with the Modern Jazz Quartet in 1958.

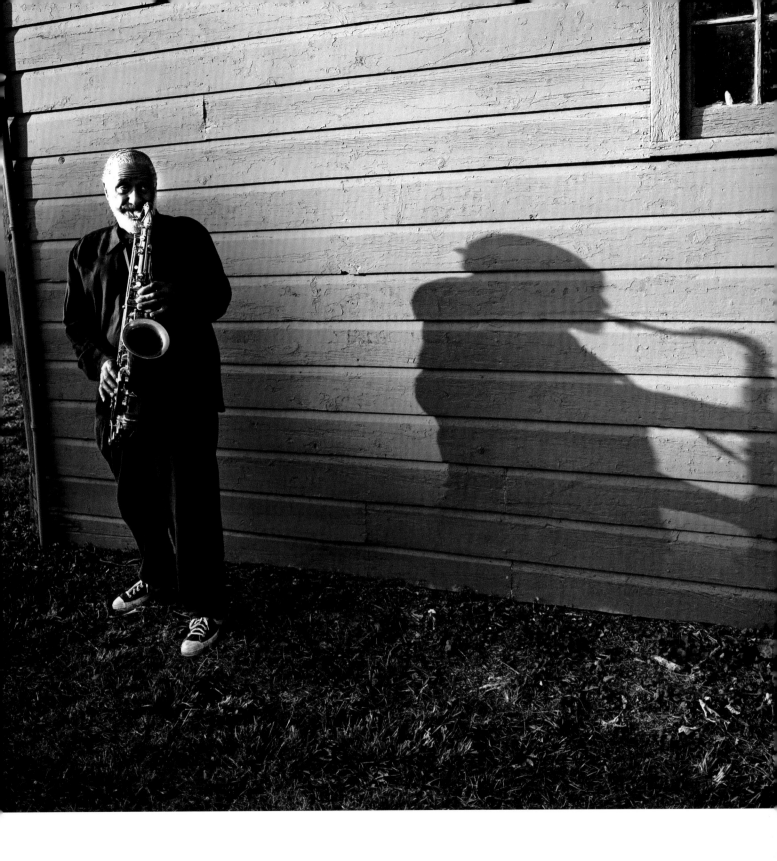

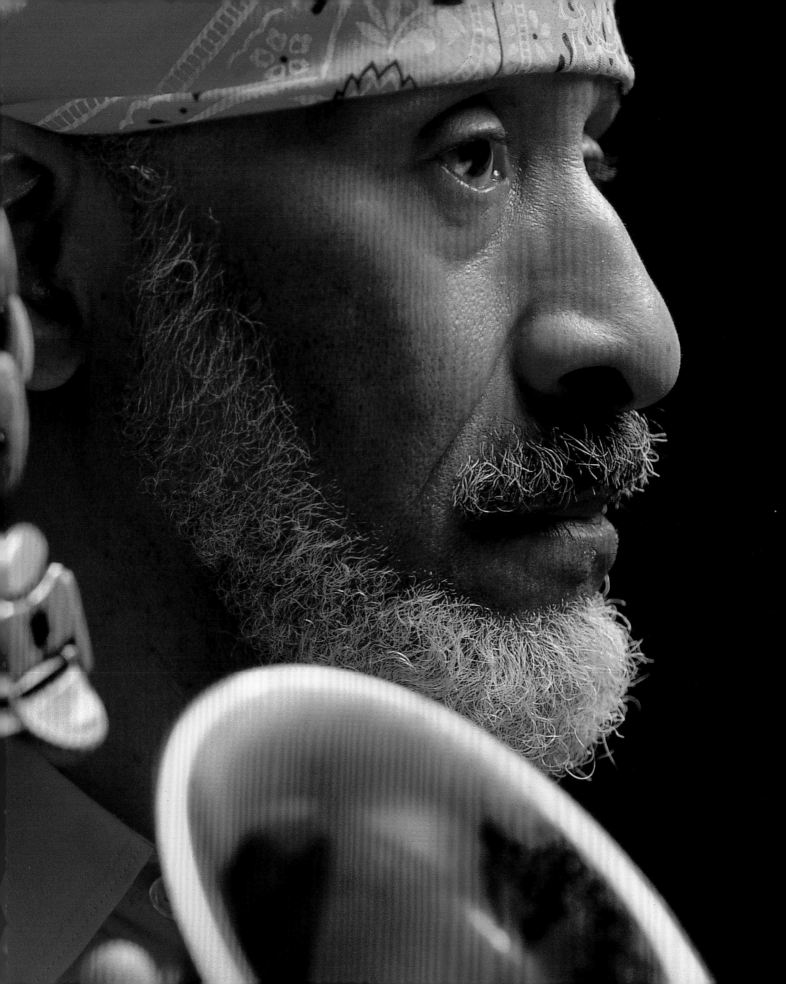

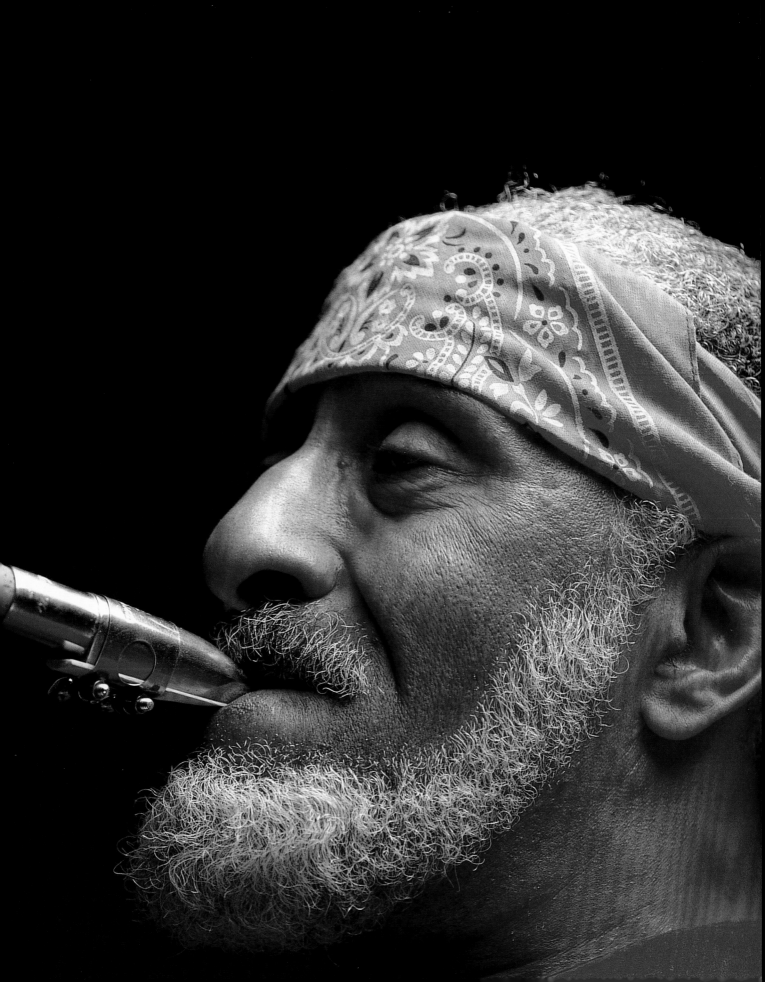

Germantown, NY,
August 1995

JOHN ——
 Sorry about this — it somehow
fall through the cracks.
 BEST WISHES
 J. R.

 P.S.
 Sorry also about Dizzy — he's
having a good time in DOG HEAVEN —
or I should say HEAVEN because it's
all the same.

This list hardly exhausts the triumphs that Rollins realized in the period that followed *Saxophone Colossus.* The disparate and at times contradictory elements of his conception, the keenly plotted developments and impulsive outbursts, the sonic coarseness and softhearted nostalgia, coexist at a similar level of inspiration on three trio albums made over the span of one year, each with its own distinct personnel. *Way Out West* (March 1957, with Ray Brown and Shelly Manne) is the most whimsical in its song selections and spry swing; *A Night at the Village Vanguard* (November 1957, with Wilbur Ware and Elvin Jones), the most raw and unbridled, with the musicians attacking the material at times like a percussion ensemble; and *Freedom Suite* (February–March 1958, with Oscar Pettiford and Max Roach), the most finely balanced, with a title track in which Rollins extended his improvisational techniques to the area of composition.

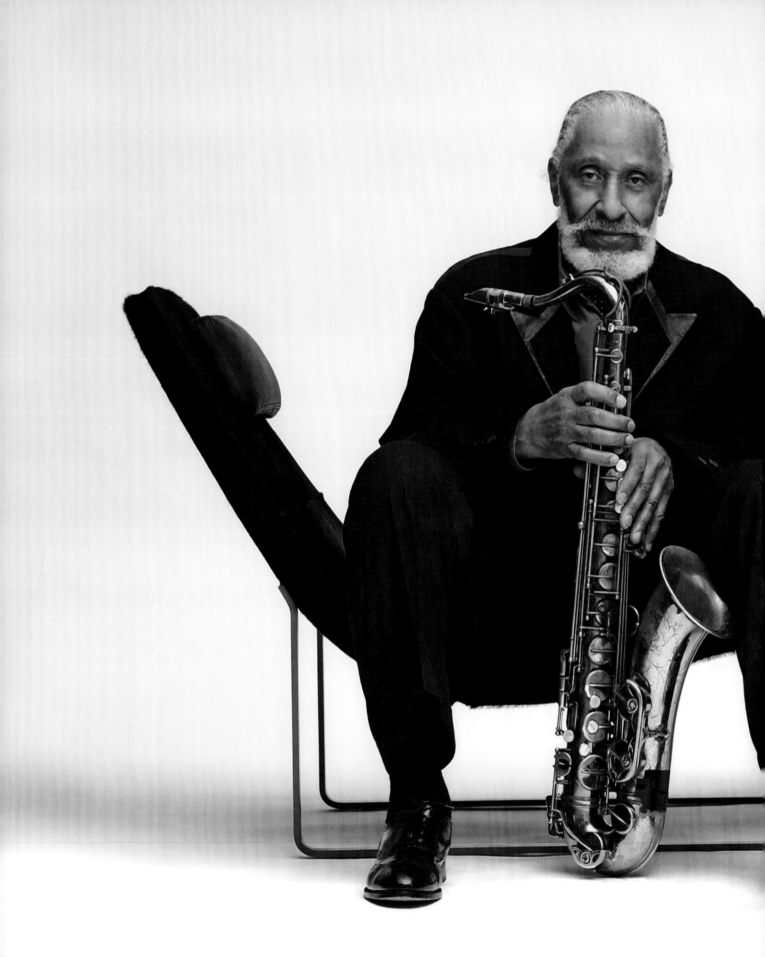

"The Freedom Suite" is a nineteen-minute opus where the three sections and through-composed interlude that appears twice as a linking device are all derived from the same melodic idea, a unity enhanced by giving tenor sax, bass, and drums uncommon equality in shaping the overall performance. Part one establishes the motif over 4 bars of medium-tempo swing, immediately followed by 4 bars where the beat is suspended, and this back-and-forth structure carries through the improvisations. After the interlude has elongated the fundamental idea into a variation in waltz tempo with the melancholy thrust of a work song, part two recasts the phrase as a ruminative ballad. The interlude then reappears, after which part three speeds forward in a 16-bar structure where the motif is recast first as reveille, then as taunt, amidst a rhythmic suspension echoing part one and a drum break that ends each chorus. Rollins' diverse strengths are magnified in this incredible performance, with the writing and improvising forming a unity unsurpassed in his work, or perhaps that of anyone else.

In addition to its musical brilliance, "The Freedom Suite" represents what at the time was jazz's most overt example of social commentary. Rollins has said, "If you are a black American, you can't help but be political. My family was always politically aware, even black nationalist, if you will, and my grandfather was a Garveyite. I couldn't be a musician and just go through life playing." He also knew from firsthand experience how artists could transcend social tensions. As a high school student, Rollins had been bused from his Harlem home to an Italian neighborhood on the East Side of Manhattan in an early effort to desegregate New York schools. "The situation was tense, and Frank Sinatra came to sing at the school after one incident. He was a big star, and an Italian-American, and it made an impression to have him come to a school in an Italian neighborhood and tell the students to settle down. Nat Cole's trio came to the school as well around this time." A decade later, Rollins would remember Sinatra's visit when he turned a song closely associated with the singer, "The House I Live In," into one of his greatest and most unexpected interpretations of standard material. To underscore his feelings on that occasion, an allusion to "Lift Every Voice and Sing" was added as a coda.

Freedom Suite was more direct and more radical. It appeared at a time when even as established a figure as Louis Armstrong was pilloried for criticizing the federal government's kid-gloves approach to entrenched segregationists,

yet made its intentions clear via a written statement that Rollins placed on the album's back cover. "The motivation was social," he explained years later. "At that time, I was getting a lot of publicity, a lot of play; but when I went to get an apartment, I couldn't get one in the part of town where I wanted to live. This evoked such a feeling in me that I figured I should say something about it."

More purely musical matters evoked other strong responses. In November 1958, the first issue of the *Jazz Review* featured "Sonny Rollins and the Challenge of Thematic Improvisation" as its lead article. This was the occasion on which Gunther Schuller declared, with support from a detailed analysis of "Blue 7," that "with Rollins thematic and structural unity have at last achieved the importance in pure improvisation that elements such as swing, melodic conception and originality of expression have already enjoyed for many years." To find Schuller, a classical composer, arguing for Rollins' importance with the same fervor that he displayed in championing Stravinsky and Schoenberg, might have signaled to the saxophonist that he, like his idol Coleman Hawkins, had transcended race through artistry. Instead, the always self-critical Rollins found himself growing more self-conscious. "I really didn't understand what I was doing until I read Gunther Schuller," he once offered. "This thing about the thematic approach, I guess it's true, but I had never thought about it. I was just playing it."

Schuller's article may have been the last straw for Rollins, who was seriously questioning whether he had earned his growing stack of ecstatic press clippings. His doubts were exacerbated by the pressures of forming groups and finding work in his new role as bandleader. With the support of his wife, Lucille, whom he had met in Chicago while a member of Roach's band, he made a decision to stop performing in 1959 that, like his previous retreat to Lexington four years earlier, was unannounced. For the next two years, living in an apartment on Manhattan's Lower East Side with no phone, and only his royalty checks and Lucille's secretarial salary for financial support, he established a pattern of daily exercise, study (of religion and philosophy as well as music), and practice that he follows to this day. "I was into metaphysics and utopian man, and Coltrane and I were swapping books on the subject during this time," he has noted. Other close friends maintained contact, but until critic Ralph Berton published a report in 1961 on his encounter with a reclusive saxophonist thinly disguised under the pseudonym Buster Jones, most of the jazz world thought that Rollins had simply disappeared.

(ABOVE LEFT)
*Carnegie Hall,
September 2007*

(LEFT)
*Sonny and his recording
engineer, Richard Corsello,
Purchase, NY, April 2007*

(ABOVE RIGHT, LEFT TO RIGHT)
*Kobie Watkins, Bob Cranshaw,
Bobby Broom, Clifton
Anderson, Kimati Dinizulu,
the band, Hamburg,
November 2008*

(RIGHT)
*Sonny in his Manhattan
apartment—a few blocks
from the World Trade Center,
April 1994*

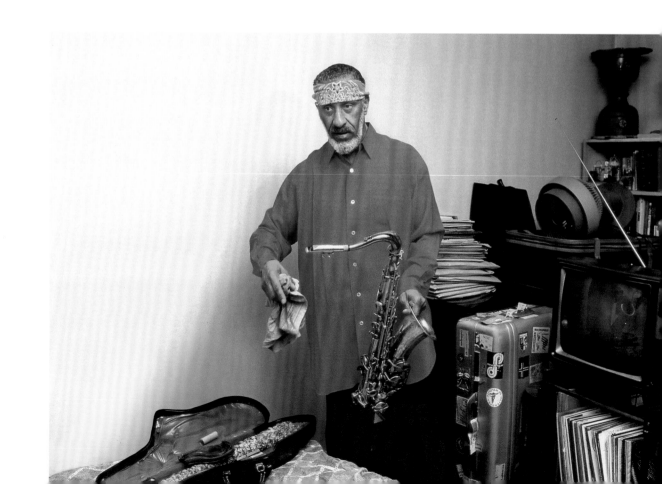

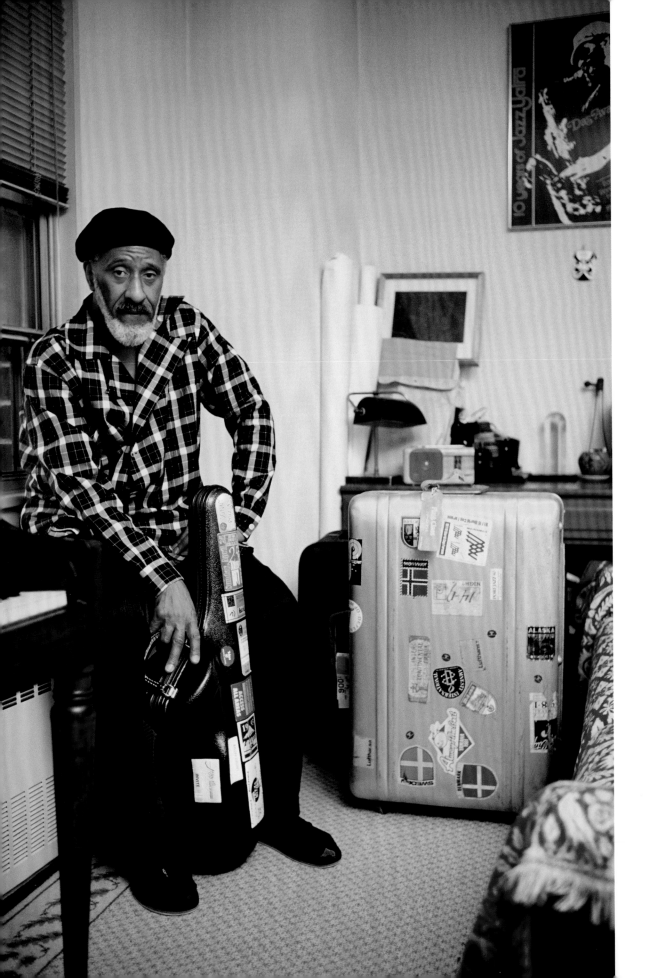

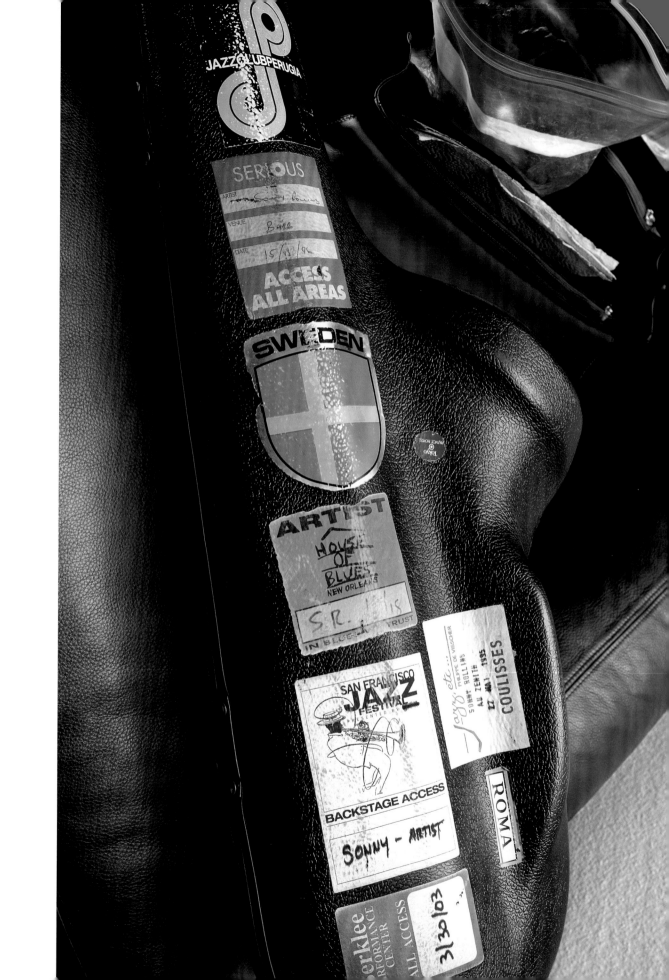

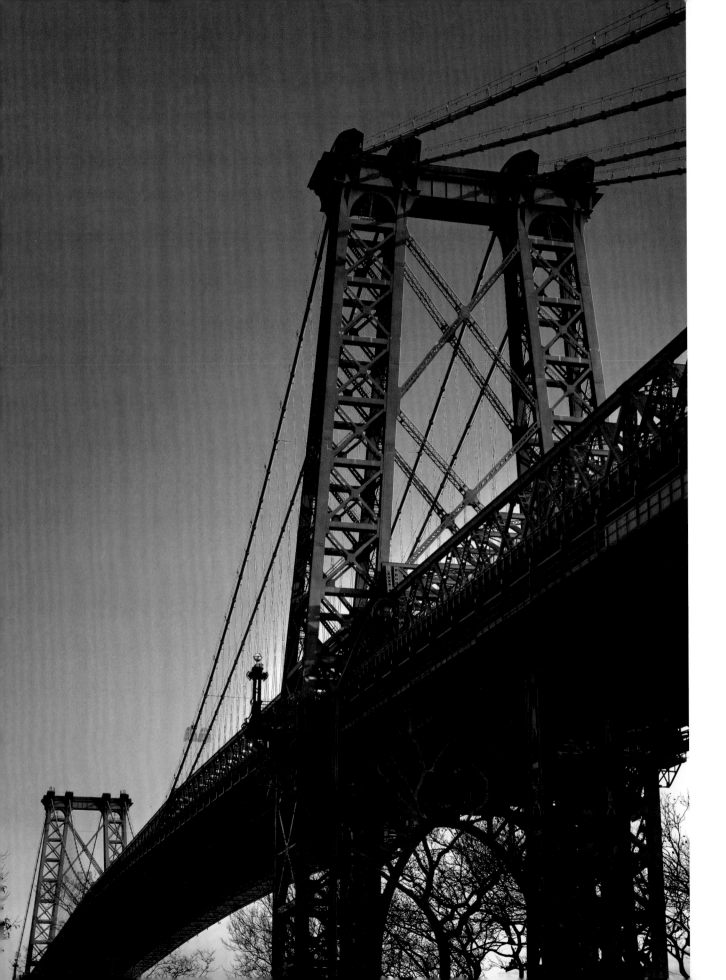

Berton encountered Rollins practicing on the Williamsburg Bridge, a location the saxophonist had adopted in deference to a pregnant neighbor in his apartment building. The notion of Rollins and horn high above the East River only reinforced his image as a colossus, while adding a dash of Garboesque mystique. The article also highlighted the questioning of his own playing that has also become central to Rollins' persona, a dissatisfaction that had little to do with the strides being made at the time by such contemporaries as Coltrane and Ornette Coleman. "My sabbatical would have happened regardless of who was on the scene," he would insist in later years. "I'm willing to get influences from anybody, but I've always been about getting my own self together." When Rollins returned to public performance in late 1961 leading a quartet featuring guitarist Jim Hall, many lamented that he had not undergone a radical transformation, while the reconfigured group he began working with six months later, with former Coleman sidemen Don Cherry and Billy Higgins in its ranks, was viewed as an overdue commitment to the nascent free jazz movement. Rollins disagreed on both counts. "People said, 'Oh, he's still playing Sonny,' when I came back from the bridge, but I can't relate to that," he noted years later. "Then, when I changed my band, I supposedly entered my avant-garde phase, but that music was still part of my essential nature. Maybe history will limit me to a style or period, but I refuse to limit myself."

For the next several years, Rollins fluctuated between the traditional and experimental in a manner that was only partially documented on the recordings he made for RCA Victor and Impulse! His most startling inflections, such as the high altissimo squeals he employs on "Lover Man" and "East Broadway Run Down," tended to appear within the context of traditional structures. "Oleo," his most daring foray with Cherry and Higgins, merely adds a traditional blues form after solos on the song's familiar "I Got Rhythm" base. There were some new wrinkles, including the undocumented beginnings of his more extended a cappella playing and the soundtrack he wrote for the film *Alfie*, and a trio performance, "Blessing in Disguise," where the core motif became sum and substance of both his improvisation and composition. Rollins continued to question his own playing, and as rock music pushed jazz further to the margins of the marketplace and the Vietnam War and civil rights movement fueled domestic unrest, he felt the need to once again escape. In 1968 he went to India for five months, then settled briefly in Japan and Europe. For most of 1969 and 1970, he even stopped practicing.

Williamsburg Bridge,
New York

151

"I wanted to find a mountaintop and stay up there," he said shortly after the conclusion of this last and most extended sabbatical. "I didn't want to have any connection with Sonny Rollins the musician. I had gotten to a point of disgust with the people in the industry and with the musicians. I had a lot of naïve notions about people having common goals in music, and when I realized that things weren't like that I just stopped everything."

In time, Rollins realized that his gift for music had to be applied regardless of imperfect circumstances. In 1972, he made three critical decisions that allowed what has proved to be his lasting return to performing. The contract he signed with Milestone Records gave him artistic control of when, what, and with whom he would record, and the relationship lasted for thirty years until he established his own Doxy imprint. While retaining his Manhattan apartment, he acquired a second home in upstate New York where he began to spend the majority of his time. Most importantly, he placed his business affairs in his wife's hands, and Lucille Rollins would remain his manager until her death in 2004. Now a typical day at home found Sonny retreating to a detached one-room studio where he would exercise, practice, read, and meditate, while Lucille fielded phone calls and reviewed contracts in the main residence.

"I try to stay away from record executives and promoters," he explained at a point a quarter-century into this arrangement, "but Lucille can function with these people. She used to run the whole chemistry department at the University of Chicago, doing all of the work while the professors were taking naps. She is in the system, and she can do stuff that would drive me completely up the wall." Over time, Lucille Rollins was able to impose increasing selectivity on where her husband performs and how he is presented. "We turn down work all of the time," Rollins emphasized, "and only take jobs that put myself, and jazz, in high esteem. I don't believe that money will bring happiness. In fact, the contrary may be true. For my own peace of mind, I may be better off without a bigger audience."

One result of this philosophy is the freedom it allows Rollins to continue speaking out on social issues, which now encompass the environment as well as civil rights. "We all know the progress of racial justice," he said at the time his *Global Warming* album appeared in 1999. "That's a hard thing to dent, because the urge to feel superior is part of human nature. But the environment is the common denominator, the equalizer that will force everybody to act together. It has superceded racism, in that everybody is going to go; and there are black people just as stupid as everyone else when it comes to believing in television and the stock market and the 'growth economy.' So this is now the big issue."

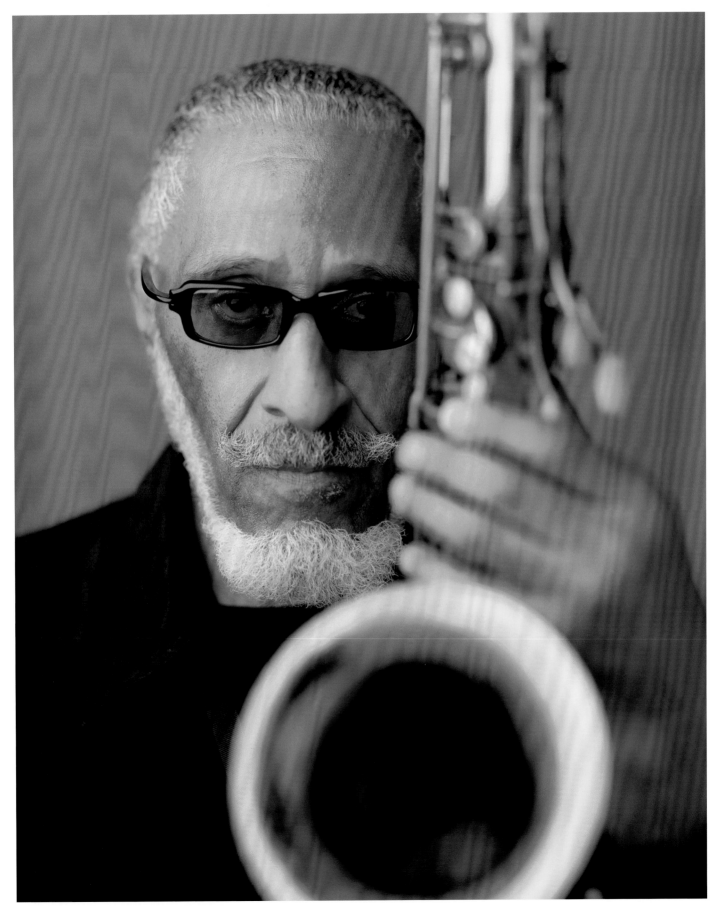

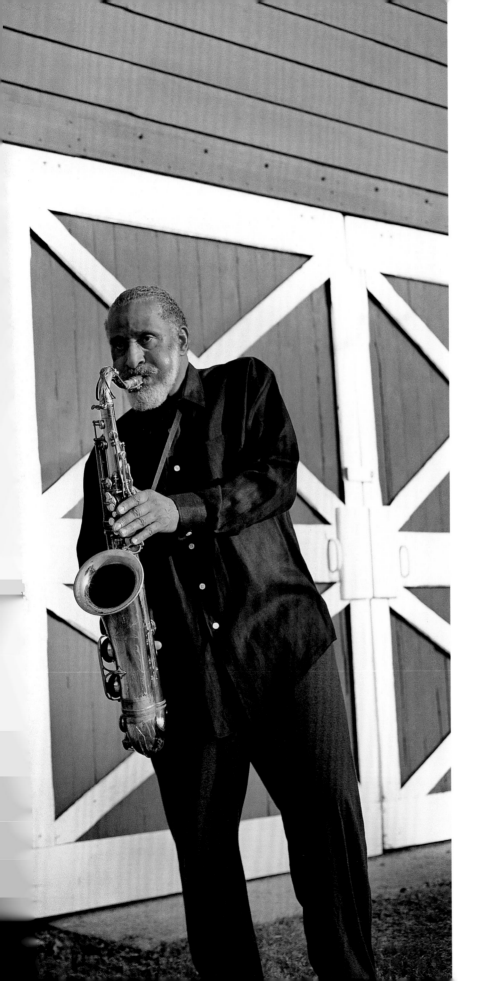

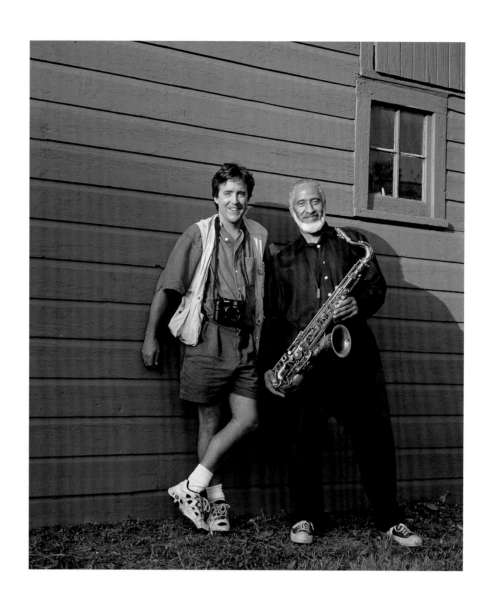

John Abbott and
Sonny Rollins,
Germantown, NY,
August 1995

In the course of his postsabbatical career, there have been numerous Rollins recordings, though few with the impact of his live performances. He continues to write memorable tunes, but studio versions of "Biji" or "Clear-Cut Boogie" (to cite two of his catchiest) pale against memories of more volcanic concert creations. Rollins admits to often being inhibited by the recording studio, which is why his best recordings of recent decades tend to emanate from live appearances, with *Don't Stop the Carnival, G-Man*, and the anthology *Road Shows Vol. 1* at the head of the list. The supreme example is the title track of *G-Man*, taped at a 1986 outdoor concert and also documented in Robert Mugge's film *Saxophone Colossus*. With little more than a seven-note riff of ancient origin serving as theme, and the relentless thrust of his rhythm section, Rollins unfurls a torrent of variations, returning to the riff on occasion as if to catch his breath. In the middle of his solo, he impulsively leapt from the stage to the orchestra pit below, landing on his back and breaking his heel in the process. Unable to stand, he continued unabated, colossal even in this supine position.

At the end of his eighth decade, Rollins presses forward, ever skeptical of the adulation that greets his every appearance and still his own most demanding critic. Calypso melodies and pop songs from his youth remain in his repertoire alongside original compositions; unaccompanied cadenzas continue to blend corkscrew runs with snippets of folk songs and nursery rhymes; and an ongoing fealty to the blues is articulated in new compositions such as "Nishi" and, when the spirit moves him, even a brief vocal. "It's all one big circle," he remarked during a September 2009 concert, a fitting summary of his own monumental and still evolving music.

Appendix

ST. THOMAS
"Whispering" – Miles Davis Sextet, January 17, 1951, *Miles Davis and Horns* (Prestige/OJC)
"Out of the Blue," "Dig" – Miles Davis Sextet, October 5, 1951, *Dig* (Prestige/OJC)
"The Stopper" – October 7, 1953, *Sonny Rollins with the Modern Jazz Quartet* (Prestige/OJC)
"Airegin," "Oleo," "Doxy" – Miles Davis Quintet, June 29, 1954, *Bags' Groove* (Prestige/OJC)
Bud Powell's Modernists – August 9, 1949, *The Amazing Bud Powell, Volume 1* (Blue Note)
"I Know" – January 17, 1951, *Sonny Rollins with the Modern Jazz Quartet*
"B. Swift," "B. Quick" – December 7, 1956, *Tour de Force* (Prestige/OJC)
"Valse Hot" [original version] – March 22, 1956, *Sonny Rollins Plus 4* (Prestige/OJC)
"Mambo Bounce" – December 17, 1951, *Sonny Rollins with the Modern Jazz Quartet*
"Mangoes" – June 11–12, 1957, *The Sound of Sonny* (Riverside/OJC)
"Bluesongo," "Jungoso" – May 14, 1962, *What's New* (RCA)
"Don't Stop the Carnival" [original version] – April 26, 1962, *The Complete RCA Victor Recordings*
"St. Thomas" [RCA version] – February 14, 1964, *Now's the Time* (RCA Victor)
"Hold 'Em Joe" – July 8, 1965, *Sonny Rollins on Impulse!*
"The Everywhere Calypso" – July 14, 1972, *Sonny Rollins' Next Album* (Milestone/OJC)
"Island Lady" [original version] – August/October 1976, *The Way I Feel* (Milestone/OJC)
"Coconut Bread" – December 9–15, 1981, *No Problem* (Milestone/OJC)
"Mava Mava" – January 23–27, 1984, *Sunny Days, Starry Nights* (Milestone)
"Duke of Iron" – September 15–25, 1987, *Dancing in the Dark* (Milestone)
"Global Warming" – February 28, 1998, *Global Warming* (Milestone)
"Don't Stop the Carnival" [live] – April 13–15, 1978, *Don't Stop the Carnival* (Milestone)
"Don't Stop the Carnival" [live] – Milestone Jazzstars, September/October 1978, *In Concert* (Milestone)
"Harlem Boys" – May 15–18, 1979, *Don't Ask* (Milestone)
"Sonny, Please" – December 20, 2005–February 10, 2006, *Sonny, Please* (Doxy)

YOU DON'T KNOW WHAT LOVE IS
"Blue Room" [take one] – Miles Davis Quintet, January 17, 1951, *Miles Davis and Horns*
"My Old Flame" – Miles Davis Quintet, October 5, 1951, *Dig*
"More Than You Know" – October 25, 1954, *Moving Out* (Prestige/OJC)
"When Your Lover Has Gone" – May 24, 1956, *Tenor Madness* (Prestige/OJC)
"Pannonica" – Thelonious Monk Quintet, October 9, 1956, *Brilliant Corners* (Riverside/OJC)
"There Is No Greater Love" – March 7, 1957, *Way Out West* (Contemporary/OJC)
"Reflections" – April 14, 1957, *Sonny Rollins, Vol. 2* (Blue Note)
"My Old Flame" – Kenny Dorham Sextet, May 27, 1957, *Jazz Contrasts* (Riverside/OJC)
"I Can't Get Started" – November 3, 1957, *A Night at the Village Vanguard* (Blue Note)
"Manhattan" – July 10, 1958, *Sonny Rollins and the Big Brass* (Verve/Metrojazz)
"I See Your Face Before Me," "My Old Flame," "Prelude to a Kiss" – July–August 1993, *Old Flames* (Milestone)
"Blue Room" – July 8, 1965, *Sonny Rollins on Impulse!*
"My Ideal" – *Don't Ask*
"Cabin in the Sky" – August 30, 1995, *Sonny Rollins + 3* (Milestone)
"A Nightingale Sang in Berkeley Square" – May 8–9, 2000, *This Is What I Do* (Milestone)
"God Bless the Child" – January 30, 1962, *The Bridge* (RCA Victor)
"Skylark" – July 1972, *Sonny Rollins' Next Album*
"Yesterdays," "Lover Man" – July 15, 1963, *Sonny Meets Hawk!* (RCA Victor)
"Summertime" – July 18, 1963, *Sonny Meets Hawk!*

STRODE RODE
Work Time – December 2, 1955 (Prestige/OJC)
Miles Davis Quintet with Rollins and Tommy Flanagan – March 16, 1956, *Collector's Items* (Prestige/OJC)
"Remembering Tommy" – *Sonny, Please*
Newk's Time – September 22, 1957 (Blue Note)
"Oleo" – Miles Davis Quintet, June 29, 1954, *Bags' Groove*
"Striver's Row" – *A Night at the Village Vanguard*
"Airegin" – Miles Davis Quintet, *Bags' Groove*
"Way Out West" – *Way Out West*

The *Saxophone Colossus* album, recorded on June 22, 1956, has been reissued on compact disc by Prestige/OJC.

"Kim" – August 16, 1986, *G-Man* (Milestone)
"Decision" – December 16, 1956, *Sonny Rollins, Vol. 1* (Blue Note)
"Paradox" – *Work Time*
"Why Don't I" – *Sonny Rollins, Vol. 2*
Freedom Suite – February 27 and March 7, 1958 (Riverside/OJC)
"The Surrey with the Fringe on Top" – *Newk's Time*
Miles Davis Sextet with Rollins and Charlie Parker – January 30, 1953, *Collector's Items*

MORITAT
"Count Your Blessings" – *Sonny Rollins Plus 4*
"Shadrack" – December 17, 1951, *Sonny Rollins with the Modern Jazz Quartet*
"There's No Business Like Show Business" – *Work Time*
"Bouncing with Bud" – *Bud Powell's Modernists*
"The Serpent's Tooth" [both takes] – Miles Davis Sextet, *Collector's Items*
"Dance of the Infidels" – *Bud Powell's Modernists*
"Tenor Madness" – *Tenor Madness*
"It Could Happen to You" – June 11 or 12, 1957, *The Sound of Sonny*
"Body and Soul" – July 10, 1958, *Sonny Rollins and the Big Brass*
"Autumn Nocturne" – *Don't Stop the Carnival*
"The Way You Look Tonight" – October 25, 1954, *Thelonious Monk/Sonny Rollins* (Prestige/OJC)
"Soloscope" – July 19, 1985, *The Solo Album* (Milestone/OJC)
"Toot, Toot, Tootsie" – *The Sound of Sonny*
"Rock-a-Bye Your Baby with a Dixie Melody" – October 20–22, 1958, *Sonny Rollins and the Contemporary Leaders* (Contemporary/OJC)
"I'm an Old Cowhand," "Wagon Wheels" – *Way Out West*
"Sweet Leilani," "The Moon of Manakoora" – *This Is What I Do*
"Dearly Beloved" – July 27–30, 1962, *Our Man in Jazz*
"I've Grown Accustomed to Her Face" – October 5, 1956, *Rollins Plays for Bird* (Prestige/OJC)
"Namely You" – *Newk's Time*
"Till There Was You" – February 27, 1958, *Freedom Suite*
"If Ever I Would Leave You" – April 18, 1962, *What's New*
"A House Is Not a Home" – July 6, 1974, *The Cutting Edge* (Milestone/OJC)
"Isn't She Lovely?" – August 3–6, 1977, *Easy Living* (Milestone/OJC)
"I'm Old Fashioned" – *Sunny Days, Starry Nights*
"Tennessee Waltz" – August 5, 1989, *Falling in Love with Jazz* (Milestone)
"Without a Song" [live version] – September 15, 2001, *Without a Song: The 9/11 Concert* (Milestone)

BLUE 7
"Vierd Blues" – Miles Davis Quintet, March 16, 1956, *Collector's Items*
"Ee-ah" – *Tour de Force*
"Ba-Lue Bolivar Ba-Lues-Are" – Thelonious Monk Quintet, October 9, 1956, *Brilliant Corners*
"Blues for Philly Joe" – *Newk's Time*
"Sonnymoon for Two" – *A Night at the Village Vanguard*
"Sumphin'" – Dizzy Gillespie Quintet, December 11, 1957, *Duets* (Verve)
"Bags' Groove" – September 3, 1958, *The Modern Jazz Quartet at Music Inn, Volume 2—Guest Artist: Sonny Rollins* (Atlantic)
"The Freedom Suite" – *Freedom Suite*
"The House I Live In" – October 5, 1956, *Sonny Boy* (Prestige/OJC)
"Lover Man" – *Sonny Meets Hawk*
"East Broadway Run Down," "Blessing in Disguise" – May 9, 1966, *East Broadway Run Down* (Impulse!)
"Oleo" [live version] – *Our Man in Jazz*
Alfie – January 26, 1966 (Impulse!)
"Biji" – October 7, 1995, *Sonny Rollins + 3*
"Clear-Cut Boogie" – February 28, 1998, *Global Warming*
"G-Man" – August 16, 1986, *G-Man*
Road Shows Vol. 1 – 1980–2006 (Doxy)
"Nishi" – *Sonny, Please* *(ALL SESSIONS UNDER THE LEADERSHIP OF SONNY ROLLINS UNLESS OTHERWISE NOTED.)*

Editor: Rebecca Kaplan
Designer: David Groom, David Meredith; Pilot NY
Production Manager: Jules Thomson

Library of Congress Cataloging-in-Publication Data

Blumenthal, Bob.
 Saxophone colossus : a portrait of Sonny Rollins / text by Bob Blumenthal;
 photographs by John Abbott.
 p. cm.
 Includes bibliographical references and index.
 ISBN 978-0-8109-9615-1 (alk. paper)
 1. Rollins, Sonny—Criticism and interpretation. 2. Rollins,
Sonny—Pictorial works. 3. Jazz musicians—United States. I. Abbott, John,
1959- II. Title.
 ML419.R64B68 2010
 788.7'165092--dc22
 [B]
 2010004972

Printed and bound in Hong Kong, China
10 9 8 7 6 5 4 3 2 1

Abrams books are available at special discounts when purchased in quantity
for premiums and promotions as well as fundraising or educational use.
Special editions can also be created to specification. For details, contact
specialmarkets@abramsbooks.com or the address below.

THE ART OF BOOKS SINCE 1949
115 West 18th Street
New York, NY 10011
www.abramsbooks.com